Ridgway

IMAGES
of America

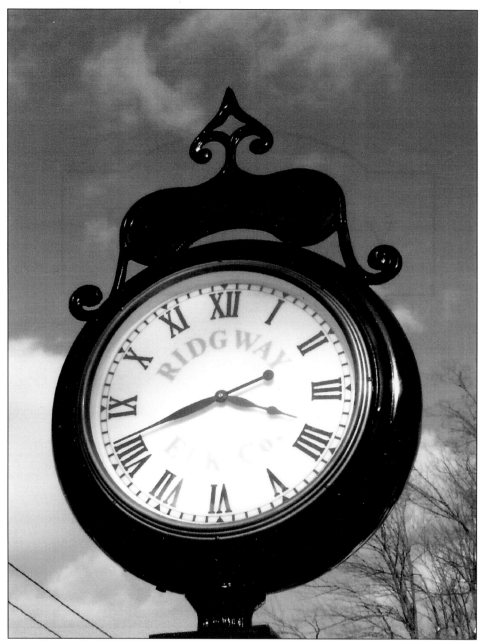

Ridgway, Elk County, is about time. Time is good to a community that remembers its past and honors those people and times by preserving what was good and beautiful about the times of their forefathers. This beautiful timepiece stands on the corner of the main intersection of Ridgway, across from the Elk County Courthouse and in front of the Ridgway Welcome Center. (Dennis McGeehan.)

On the cover: Here is a view of Ridgway's past when youths could avidly watch road repairs, as a disinterested dog ambles down the middle of Main Street. In the left background a cigar store Indian greets shoppers by a jewelry store with sidewalk clocks. This is the corner of Main and North Broad Streets. The Hyde House hotel is on the right. (Elk County Historical Society.)

Dennis McGeehan

Copyright © 2008 by Dennis McGeehan
ISBN 978-0-7385-6303-9

Published by Arcadia Publishing
Charleston, South Carolina

Printed in the United States of America

Library of Congress Catalog Card Number: 2008924493

For all general information contact Arcadia Publishing at:
Telephone 843-853-2070
Fax 843-853-0044
E-mail sales@arcadiapublishing.com
For customer service and orders:
Toll-Free 1-888-313-2665

Visit us on the Internet at www.arcadiapublishing.com

Dedicated to Deb, who shares the road and the sky with me.

Contents

Acknowledgments 6

Introduction 7

1. Business Life 9

2. Building a Community 53

3. The Bonds of Society 93

ACKNOWLEDGMENTS

I would like to thank all of the people who helped me in the preparation of this book: Debra McGeehan for her tireless work at every stage of the process, without whom this book would not have been possible; Tim Leathers and Glenn Freeburg for their initiative, historical insight, and suggestions; Mark Wendel and Dave Woods for the use of their collections; Mary Kalinowski for her assistance in choosing and access to images; Bob Imhoff for his love of Ridgway and for the use of his historical knowledge; Georgeanne Freeburg for her editing; Krista Zamerowski and Darlene Coder for enabling my art; Lawrence and Maureen Buehler for keeping the logging legend alive; David and Dawn Jardini for preserving the past; Dave Love for his love and care of the river; John T. and Elizabeth D. McGeehan; Edgar and Dorothy Schnarrs; Dr. Vernon Ordiway; and the Elk County Historical Society for their valuable archival work.

All photographs, unless otherwise noted, are courtesy of the Elk County Historical Society.

INTRODUCTION

Ridgway is the county seat of Elk County, located in the scenic and rugged Allegheny Mountains of central Pennsylvania. The area is the headwaters of the Clarion River, which flows into the Allegheny River and on to Pittsburgh, the gateway to the west in the settlement of our nation. Ridgway played an important role in that colorful era that was the lumbering boom. Fortunes were made in timber from the heavily forested mountains around Ridgway. Lumber camps, log drives, timber rafting, sawmills, tanneries, and the mansions of the lumber barons fill the pages of Ridgway's history. When the center of the timbering industry moved west, Ridgway never let the vitality of the town decline. Ridgway adapted to modern times and ways, while preserving its past. The ambitious Ridgway residents have made the town a successful example of the combination of business, industry and tourism that is successful in the American economy today.

The story of Ridgway begins in the early 1800s, when wealthy Philadelphia Quaker businessman Jacob Ridgway purchased sizable tracts of land in north central Pennsylvania. Ridgway sent his agent, James Lyle Gillis, to begin the town that would bear his name in 1821. In 1823, Gillis was instrumental in chartering the Milesburg-Smethport Turnpike, which put Ridgway on the map with a means of overland transportation. Gillis was also the prime mover in creating Elk County in 1843. Ridgway had been part of Jefferson County and the 40-mile distance to their county seat prompted Gillis to support the creation of a new county with its county seat located at Ridgway.

The wealth of Ridgway has always been in its trees. The Allegheny highlands are heavily forested and the founding of Ridgway coincided with a period in our nation's history when great expansion was taking place and the need for lumber for building was crucial. Ridgway was perfectly situated to take advantage of this opportunity. The Clarion River became a highway for wood products flowing downriver to Pittsburgh. The Pennsylvania Railroad and the Baltimore and Ohio Railroad eventually made their way into Ridgway and the town's prosperity was insured. In 1888, when a new paper mill opened upriver in nearby Johnsonburg, the county's business boomed.

Joseph Smith Hyde and James Knox Polk (J. K. P.) Hall were two prominent early entrepreneurs from Ridgway's early history that were involved in many of the community's functions that led to the success of the town. They were both primarily involved in the lumbering business but became involved in many other civic endeavors and ventures. Ridgway has played host to many important businesses over the years. The most famous firm of Ridgway was the Hyde-Murphy Company. The company made high-end specialty wood products and was in the construction

business. The quality and elegance of their woodwork was famous nationwide. The Russell Car and Snow Plow Company made snowplows for locomotives and railroad cars. The Ridgway Manufacturing Company, which later became the Elliott Company, created a base of industrial growth in Ridgway and was an important part of the war effort in World War II. Today Ridgway is home to many small industrial businesses primarily in the powdered metal and tool and die fields of which the area is the worldwide leader.

Ridgway has always had a lively commercial marketplace. Many of these stores and shops are gone but fondly remembered. Ridgway's historic Main Street has been lovingly restored and is conducive to commerce. The spirit of entrepreneurial optimism lives on in the people of Ridgway. Business ventures fail, succeed, and fail. But the energy to continue to prosper never wanes. The people of Ridgway truly enjoy serving, patronizing, and supporting their neighbors' commercial ventures.

Ridgway has always enjoyed a lively artistic and cultural scene. From the grand Ridgway Opera House to Ridgway's beautifully restored Victorian domestic architecture, the town still has a thriving cultural life. Ridgway is home to the Elk County Council of the Arts. The residents take pride in the heritage and the culture of their past and develop a sense of place in the present to interpret their future. The people of Ridgway work, play, mourn, celebrate, and worship as members of a dynamic community. Their teams have won titles and their citizens have achieved glory. Ridgway has always been active in its duty to serve the nation in peacetime and to defend it in times of war, past and present. Many Ridgway residents have served in far off places to keep America proud and some of its residents have not returned from that noble cause. Ridgway is proud to honor both.

Each year in February, Ridgway is host to a world-renowned gathering called the Ridgway Chainsaw Carvers Rendezvous. The smell of sawdust, gasoline, and chain oil fills the streets as pick up trucks and more flamboyant vehicles bearing license plates from around the country cruise down Main Street with clever creations carved in wood riding in their beds. Lumberjacks Restaurant is filled with lumberjacks and the smell of festival food fills the air. The sidewalks of Ridgway are alive with shoppers sampling the lively antique and collectibles market of the city. The sound of exotic accents and foreign tongues can be heard bargaining for local souvenirs. The event culminates with a colorful public auction benefiting charity and then the fantastic creatures, mythical beings, and wildlife all carved in wood ride their trucks out of town wending their way to places unknown.

Ridgway is a viewable city. From the broad, spacious Main Street one can see the still-forested hills from which Ridgway made its fortune. One can hear the birds sing in the trees that were so essential to the prosperity of Ridgway and take comfort that the forests have been preserved. Ridgway still engages in timbering. The Buehler Lumber Company is still located in downtown Ridgway. One can still see the log trucks roll through the town and take pride that the forests are being productive and being preserved. Ridgway is part of the Pennsylvania Wilds Heritage Region. One can still rent a canoe in downtown Ridgway and see the city from the river while canoeing into the Allegheny National Forest. One can still stroll the tree-lined streets of this peaceful town and see its artistry. While much of the forests of the past have flowed downriver to build the growing nation, much of the beautiful wood craftsmanship is preserved in the mansions of the former lumber barons. One can still experience these grand works of art and view interpretive photo boards portraying other treasures lost to time. The city has been changed by fire and by flood, by tragedy and by triumph, by poor times and by prosperous times, but never by desperation or despair, because the people of Ridgway have always had the vision and the vitality to create a spiritual place to bequeath to their descendants. The vital seeds of this special place called Ridgway are not the buildings or the businesses but the people. Buildings crumble and businesses become fond memories but the people remain, doing the same thing that their ancestors did. Preserving the idea that was Ridgway and watching it thrive. The ghosts of Ridgway's past live on in this book to fondly remember the "Lily of the Valley."

One

BUSINESS LIFE

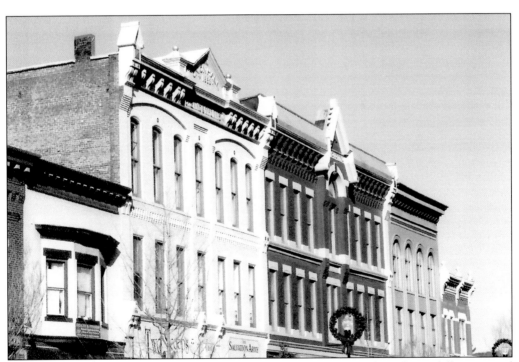

Ridgway's central business district and historic downtown area have been beautifully preserved by the civic-minded citizens that take such pride in the appearance of their community. The buildings, from left to right, are the Wellness Building, the Schoening and Maginnis Union Hall, the Grand Central Building, the old Smith Brothers Company Department Store building, and the old Elk County National Bank Building. (Dennis McGeehan.)

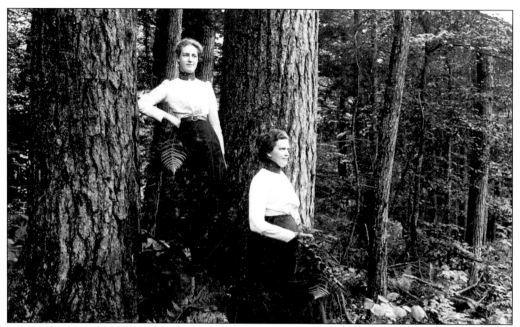

History remembers the frontiersmen, but remember, there were also frontierswomen. This pair of strong, stately ladies is framed by a pair of magnificent specimens of the virgin forest that greeted pioneers to Elk County. The people that ventured into this wilderness were vigorous and determined. These proud men and women created lives and towns whose descendants reflect their faith and spirit today.

First came the roads into the big woods. Rutted, washed out, nearly impassable roads, often along watercourses, penetrated the bypassed wilderness of north central Pennsylvania, long after the American frontier had moved west. When wood was needed to build the growing country, the saws thirsted for the big timber of Elk County. The Milesburg-Smethport Turnpike put Ridgway on the map. This primitive road is along Elk Creek east of Ridgway.

Next came railroads to haul out the lumber to hungry sawmills that sprang up like mushrooms throughout the region. Narrow-gauge railroads threaded their way through the towering trees to connect the myriad lumber camps, with their hardy lumberjacks, to the sawmills and planing mills to finish the wood products that would beautify area lumber barons' mansions and build towns. The rivers became highways for the demand of the resource.

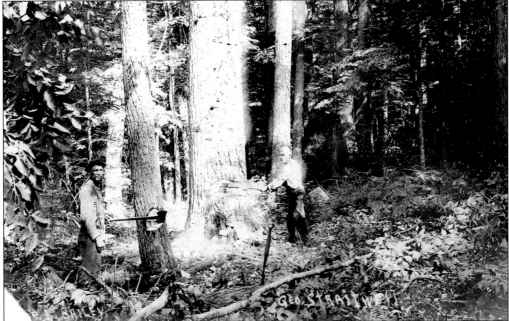

When the first settlers arrived, they found a canopy of trees that shaded the forest floor. Often the first tree cut would not fall because the forest was so dense. The double-bitted axe and the crosscut saw were the tools of the trade for the pioneer. Only a vision of the future could sustain the lumberjack at the start of his task. This scene is from Big Mill Creek.

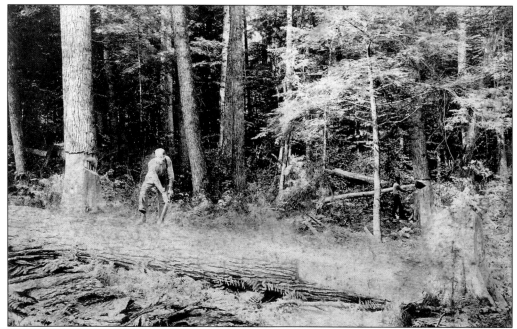

After the tree was felled, the trunk was stripped of its bark. The bark was used to tan leather in area tanneries. These wood by-product industries were important to the economy of the region. Elk County became important to the national economy when they started to tan the hides of buffalo that were shipped from the American West. This scene is from the Highland area.

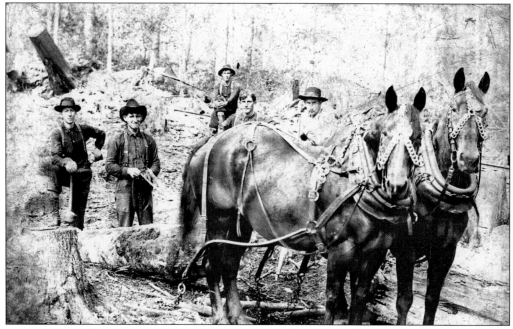

A good team of horses was a valuable asset in the timberlands and the animals were well cared for. The teamsters were proud of their working partners. The men in this photograph are set amid the stumps of the area being cut. The horses are in the process of dragging a cut log out to a staging area.

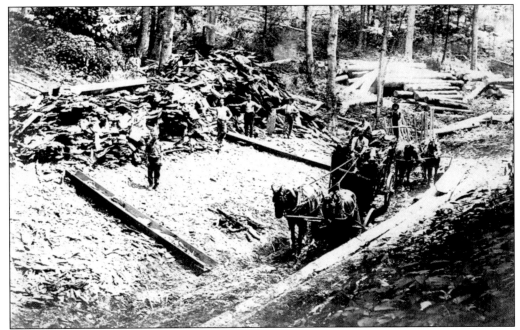

Illustrated in this logging scene are many details of the industry. At the upper right are logs that have been stripped of their bark. The bark is lying in piles at the upper left. The bark is being loaded onto horse-drawn wagons to be delivered to local tanneries where it was an essential raw material. Also visible, is a log slide along the road used to move logs.

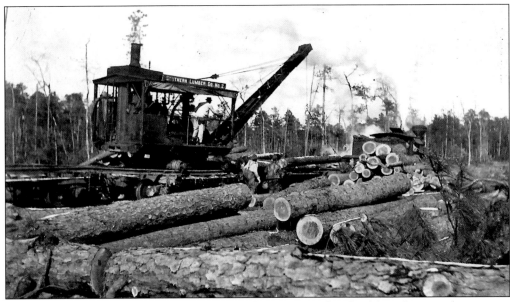

A log loader is shown in operation. This machine was used to load logs from a siding onto a railroad flatcar. This device could load the heaviest logs. The logger on the siding threw a pair of tongs to grab the middle of the log and then had to be nimble enough to get out of the way of the heavy log. Sometimes they were not. (Dave Woods.)

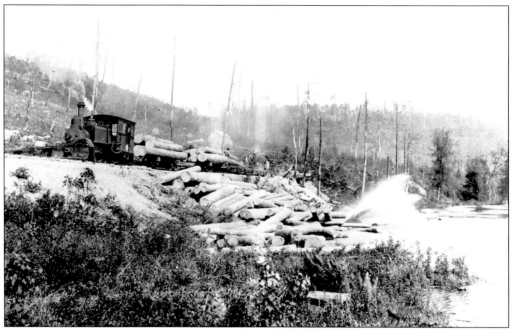

After logs were cut and loaded onto narrow-gauge railroads, they were delivered to area sawmills for processing. In this photograph, the logs are being rolled down a slope into a splash pond. This was dangerous work as the logs were sometimes stuck or frozen together. A logger had to use a pry bar to release the logs and then get out of the way to avoid being crushed.

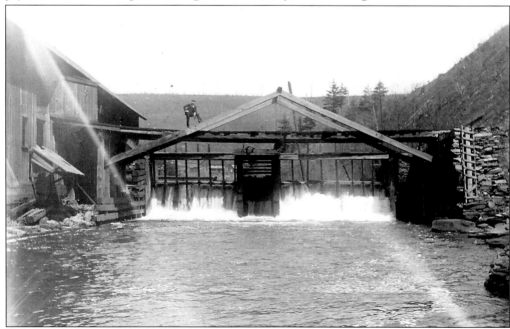

Byron Ely operated a sawmill on Elk Creek along Front Street in Ridgway. This is a photograph of the dam that created his millpond. The mill was located along the creek where the Ridgway Color and Chemical Company plant stood. Ely came to Ridgway in 1836 and continued in the lumbering business into the 20th century.

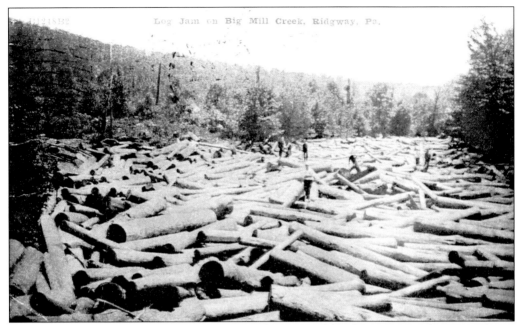

This log jam on Big Mill Creek west of Ridgway shows how difficult it was to get logs to market in the early days of timbering. Log jams often had to be dynamited. Later driving logs individually by the pond freshet method gave way to log rafts and eventually to transport by railroads and today trucks. (Dave Woods.)

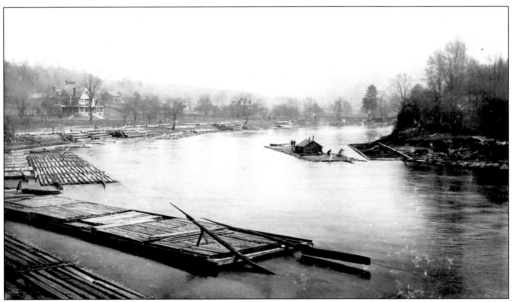

Many of the trees cut in the Ridgway area ended up here at Cooksburg on the Clarion River where rafts were assembled to be floated on the spring tide to sawmills as far away as Pittsburgh. Note the shanty on one of the rafts. The rafts were broken apart to be cut and the raftsmen walked back upriver to start over. It was a wild and dangerous endeavor.

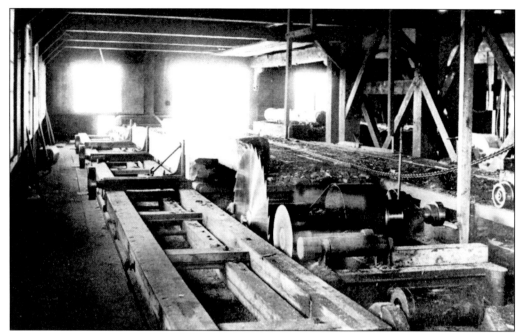

This is a typical scene inside a sawmill of the area. At the upper center, an unfinished log can be seen entering the mill. Through a series of chains, belts, and pulleys, the log arrives at the big saw and is processed into the squared timber visible on the cutting bed at the center. Expert sawyers were always in demand in the region.

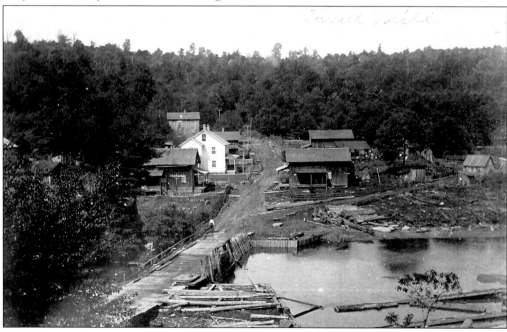

This is a scene at Laurel Mill, west of Ridgway on Big Mill Creek. The Dickinson brothers operated a sawmill at this location. They were the sons of George Dickinson, an early lumber pioneer who operated a sawmill in Ridgway's west end. Today Laurel Mill is the site of a recreational park and baseball fields.

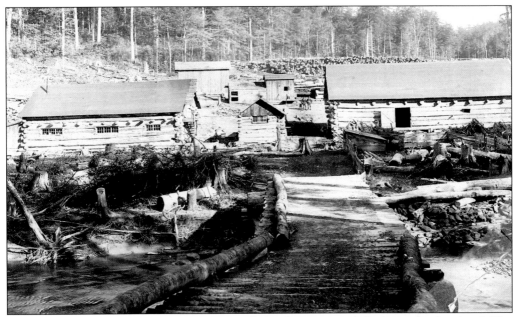

Frank McChesney's logging camp on Big Mill Creek was a typical operation of its kind. The camp was designed to process large amounts of timber at minimal expense. Crude log huts and bridges set amid the product from start to finish are evident. Note the scattered tree stumps in the foreground and the large log pile in the background. Two wood hicks survey the scene in the center of the photograph.

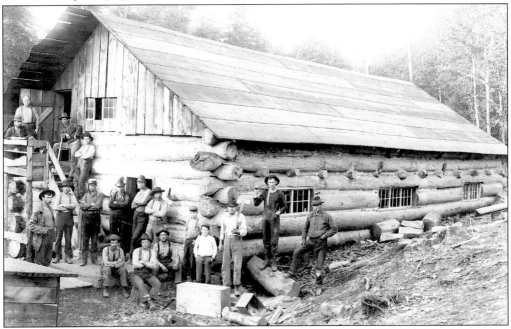

This logging camp is built from unfinished logs. The work was hard and the food was good and plentiful, and after the evening meal many of the wood hicks enjoyed a peaceful pipe of tobacco. Even relaxing, several of the lumberjacks are seen posing with their everyday tool, the double-bitted axe.

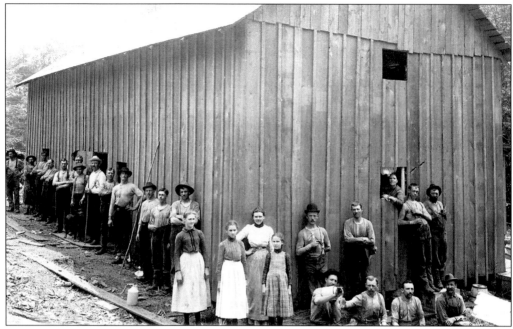

Logging camp architecture was utilitarian. The buildings were not meant to look beautiful, only to be useful. They were only used for eating and sleeping. This extremely plain building has only crude windows and doors cut out for the inhabitants. Note the two wood hicks enjoying themselves to a little refreshment from their jug at the bottom, right.

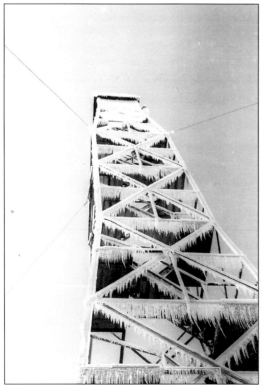

The valuable forests that surround Ridgway were protected for many years by the Boot Jack fire tower. Many of these towers still stand in Pennsylvania. Always a seasonal job, the life of a fire tower watchman was one of boredom punctuated by an occasional, unwelcome alarm for the reason of their existence, fire in the big woods. The tower on this icy, off-season day would have been impossible to scale.

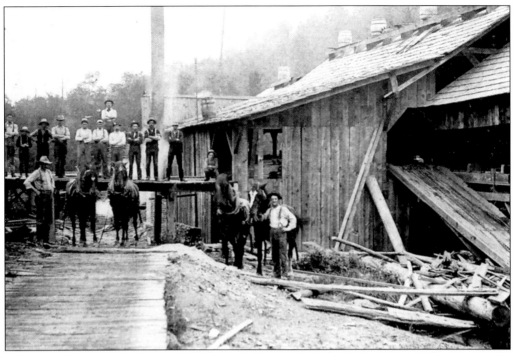

This is a typical sawmill from the Elk County area. On the right is a jack slip, a ramp for dragging logs into the saw beds. Finished lumber was carted out the ramp on the left to storage yards. Lumber camps often had a line of barrels on the roof's ridgeline to catch rainwater. If there was a fire the barrels would fall through the building and help put the fire out.

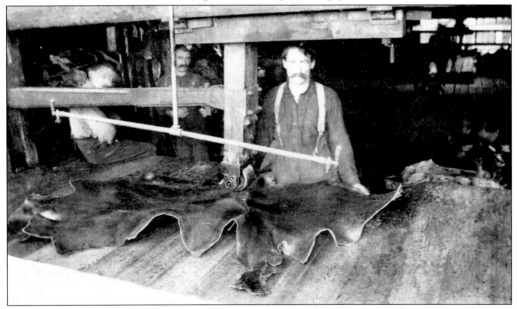

Tanning was an important industry in Elk County that utilized the by-products of the timbering trade. Hemlock bark contains tannic acid, which is used in the tanning process. Eventually the bark became more important than the wood, and trees were cut just for their bark. In this scene, a worker is rolling the leather in the Portland Mills tannery.

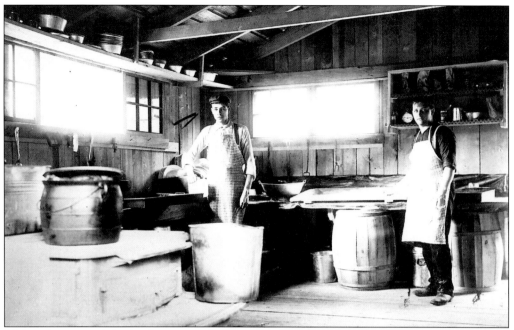

Although many of the lumber camps had female cooks, male chefs upheld the pride of their gender in the culinary arts as is evidenced in this scene inside a loggers' kitchen. From all accounts, the food at the lumber camps was both good and plentiful. Large pots and barrels were needed to feed the crew.

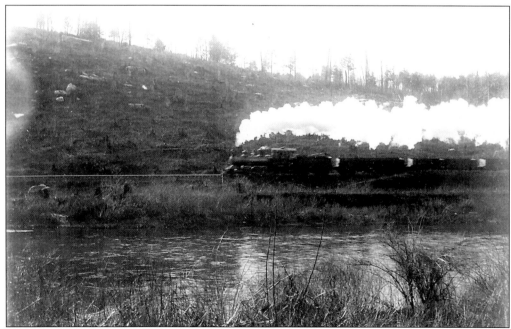

Here is a Buffalo, Rochester and Pittsburgh Railroad locomotive steaming along the Clarion River near Ridgway. This line was eventually acquired by the Baltimore and Ohio Railroad. The Pennsylvania Railroad also ran through Ridgway. Railroads with their connections to other markets were extremely important in the early years of Ridgway's growth.

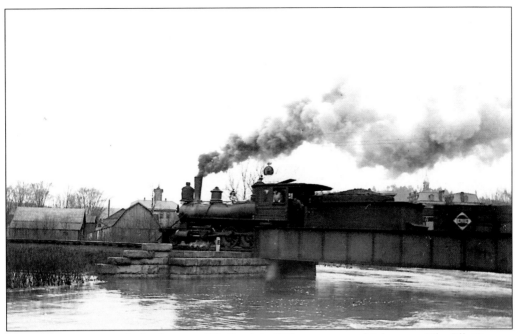

This train is crossing the bridge over Elk Creek in Ridgway at very high water. The Elk County Courthouse can be seen through the smoke on the right skyline and on the left skyline, the cupola of an early Ridgway school. The mansard roof under the courthouse tower is the Ross House, later the Salberg Hotel.

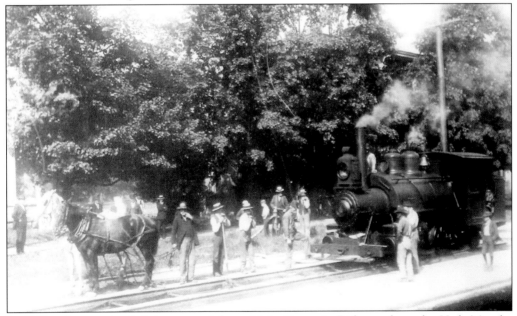

In 1899, a locomotive is being moved down Main Street in Ridgway from the Hyde-Murphy Company to the Ridgway and Clearfield Railroad. Note that a temporary set of rails has been laid on the street and that the rails cover only a short distance. There are no rails behind the locomotive. As the locomotive, which is under power, is hauled by the horses, the rails are moved forward. (Lawrence Buehler.)

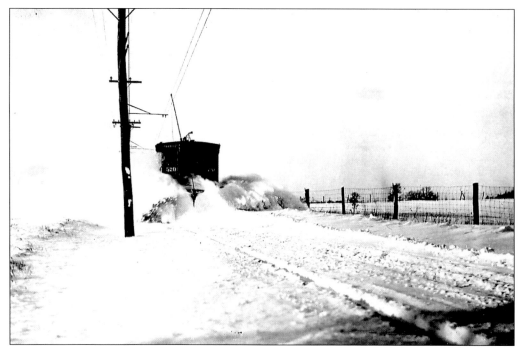
The Russell Car and Snow Plow Company on Front Street manufactured snowplows used by trains. The business operated in Ridgway for many years. This photograph shows that the company's product was sorely needed on the railroad tracks of wintertime Elk County. The snowplow locomotive was a common and colorful scene in the Ridgway area. (Tim Leathers.)

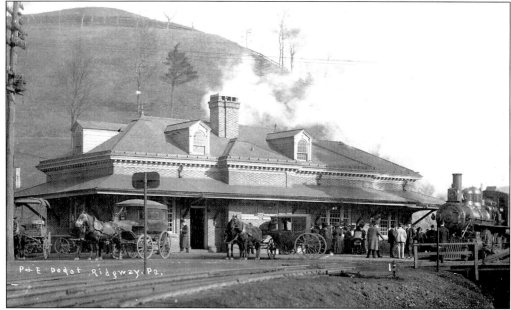
In years gone by, railroad stations were the center of activity in a small rural town. Here is the Pennsylvania Railroad station on North Broad Street at a peak of activity. Steam and smoke billow around the facility as a locomotive has pulled in and horse carriages await their fares. Osterhout Hill looms in the background. (Dave Woods.)

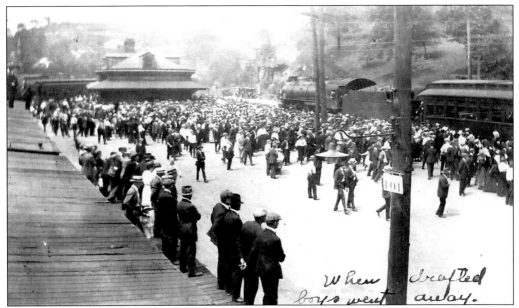

This is a view of the Pennsylvania Railroad's passenger depot on North Broad Street in Ridgway. This gathering is a poignant moment because the annotation reads "when drafted boys went away." Servicemen going off to war was always a bittersweet celebration as not all of the departed may return. Note the locomotive and coal car during the age of steam railroading. (Glenn Freeburg.)

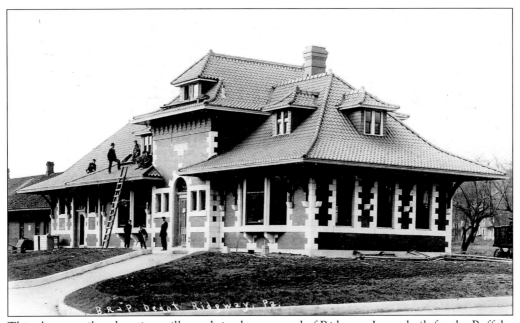

This elegant railroad station still stands in the west end of Ridgway. It was built for the Buffalo, Rochester and Pittsburgh Railroad line that was later taken over by the Baltimore and Ohio Railroad. The line originally was created to give Rochester businessmen access to the coalfields of Pennsylvania. Ridgway, at one time, had several trains a day utilizing this beautiful station, including freight and passenger sleeper cars. (Mark Wendel.)

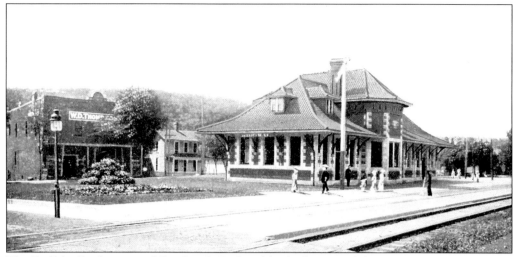

The Buffalo, Rochester and Pittsburgh Railroad built this graceful passenger station in 1906. The major freight of the Buffalo, Rochester and Pittsburgh Railroad was coal and coke to the Great Lakes. In 1932, the Baltimore and Ohio Railroad purchased the Buffalo, Rochester and Pittsburgh Railroad and took over its trackage and stations. In the left background is the Thompson Store on West Main Street. (Glenn Freeburg.)

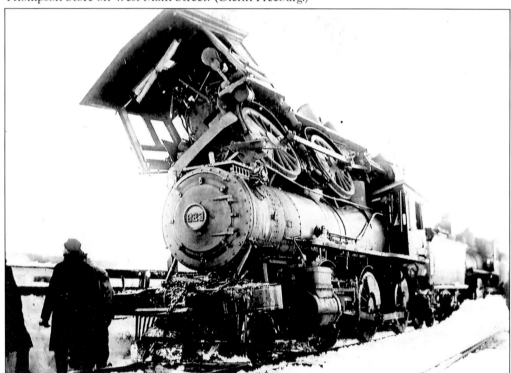

Ridgway was a hub of railroad activity in times past. The Pennsylvania Railroad and the Baltimore and Ohio Railroad both had stations in Ridgway. There were also many narrow-gauge logging railroads to access the timber of the region. With all of this railroad traffic, it was inevitable that mishaps occurred. This photograph shows the result of a spectacular collision that ended up with one locomotive resting on top of another. (Tim Leathers.)

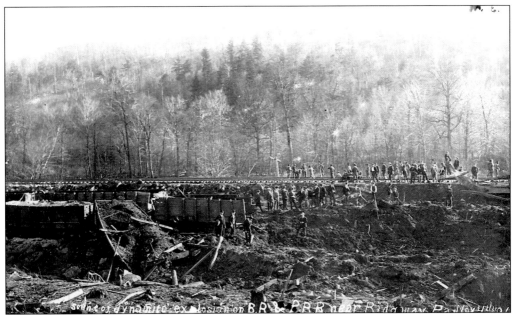

On November 4, 1906, a boxcar of dynamite on a siding exploded causing this devastation on the Buffalo, Rochester and Pittsburgh Railroad at Big Mill Creek. The explosion damaged 25 railroad cars and made a crater 25 feet deep and 30 feet wide in the ground that the many spectators are marveling at in this photograph. Railroading was a dangerous business even if the cargo was not highly explosive. (Mark Wendel.)

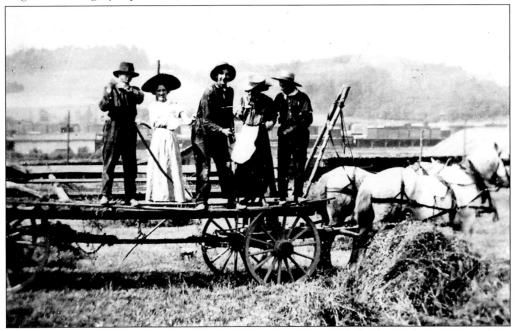

When the day's work was done, it was time to pose on top of the horse-drawn wagon for a photograph. These straw-hatted and bonneted farmers appear to be clowning around and happy with their chosen profession. At the end of the harvest, barn dances and celebrations were common.

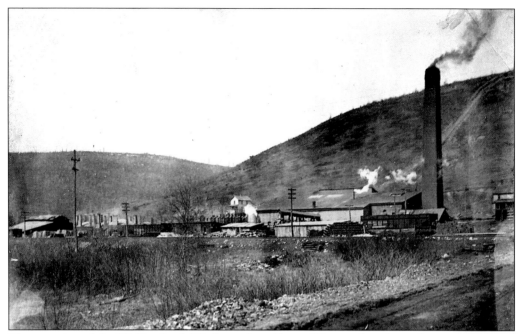

This is a view of the Elk Fire Brick Works in the village of Daguscahonda on the eastern edge of Ridgway Township. In this view, the beehive kilns with their small smokestacks are located on the left of the photograph. Behind the large smokestack on the right of the photograph can be seen the inclined railway that delivered the clay-bearing rock from mines on top of the hill.

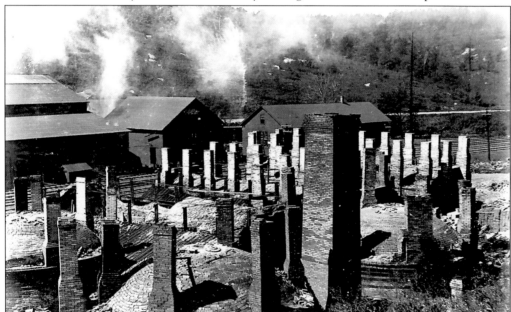

The Ridgway Brick Works is shown with its many beehive kilns sprouting multiple smokestacks. This business was located on North Broad Street. The abundance of clay ore in the Ridgway area created many jobs and businesses. Bricks for home building and other purposes were needed. During the Depression, transients riding the rails used to sleep near the ovens for warmth while seeking work. (Glenn Freeburg.)

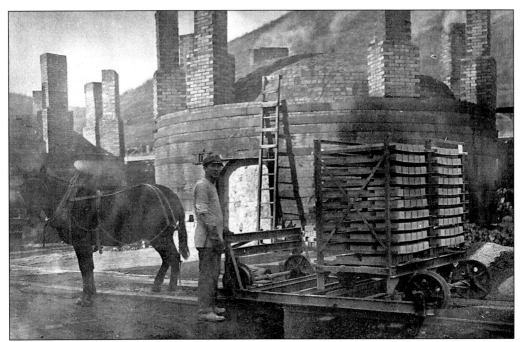

This is a view of a beehive kiln at the Elk Fire Brick Works in Daguscahonda. After forming, the bricks were hauled by mule carts on special racks and placed in the kiln. The kiln was then sealed up and fired. The baking made the bricks heat resistant. The clay was mined on the property.

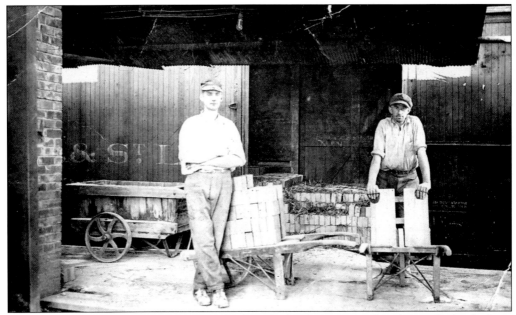

Workers at the Elk Fire Brick Works are loading fire bricks onto a railroad car. The bricks have been baked in one of many beehive ovens to make them heat resistant. The men use specially designed handcarts to move the bricks. Note that straw is being used to pack the bricks to prevent breakage during transport.

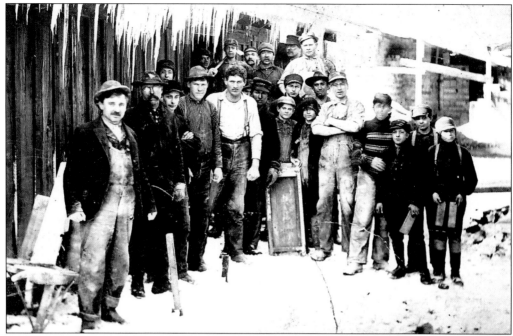

An Elk Fire Brick Company work crew poses for a photograph during the winter in 1906. Most of the men and boys are dressed warmly because the facility was not heated since there were so many ovens firing bricks nearby. On this job, the workers were usually too hot or too cold.

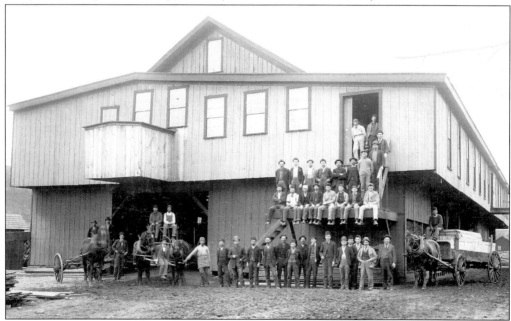

Lumber barons J. S. and W. H. Hyde of Ridgway and Walter P. Murphy of Freeport, founded the Hyde-Murphy Company. This business was an integral part of Ridgway's growth. They made fine custom-made, specialty wood products for the building trade. Murphy is seen in the photograph standing at the far right beside the horse-drawn wagon that is seen loaded with some of the company's products.

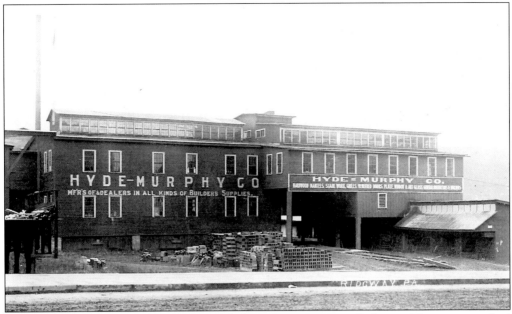

The Hyde-Murphy Company was located along Race Street in Ridgway. The company had a reputation for manufacturing high-quality woodwork locally and throughout the nation. In 1910, the factory building, lumber yard, and a large portion of Ridgway's business district burned in a spectacular fire. Within a year, the business was operating in a new brick building. (Mark Wendel.)

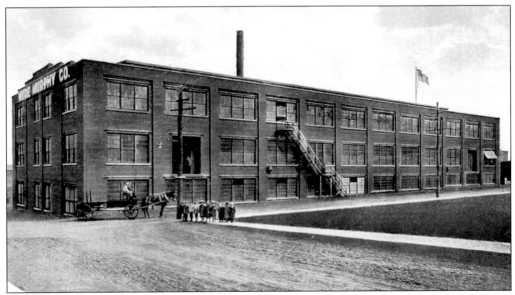

The Hyde-Murphy Company's new brick building is shown. This facility replaced the original wooden building after the disastrous fire of 1910. This company built many of the homes in Ridgway and was famous for its woodwork interiors. In this scene, a group of schoolchildren is seen on a tour of the plant. (Glenn Freeburg.)

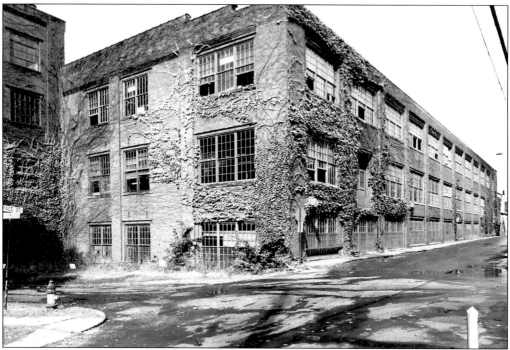

The Hyde-Murphy Company's new brick building stood at the corner of North Mill and Race Streets in Ridgway. It has since been demolished. The company manufactured wood finishing products and was an important local employer. Samuel P. Murphy guided the business after his father's death, and when the business closed in 1961, after 85 years, it was the oldest existing industry in Elk County.

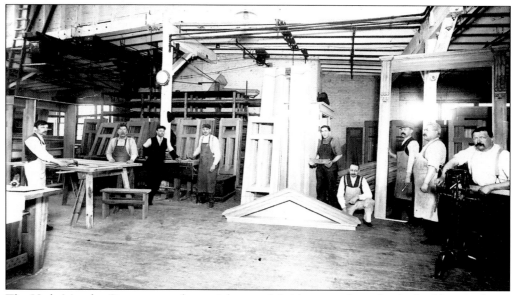

The Hyde-Murphy Company made specialty wood-finishing products for the building trades in Ridgway. The company had a reputation for high quality, and much of its work is still on display in the elegant Victorian mansions of the former area lumber barons preserved in Ridgway. In this scene inside the factory, the workers are working on door jambs, sashes, and a pediment.

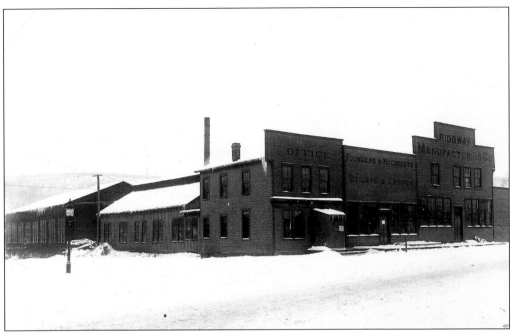

The Ridgway Manufacturing Company was one of the most important businesses in the history of Ridgway. It came into being with the consolidation of the Ridgway Iron Works and the J. H. M'Ewen Manufacturing Company. The business specialized in engines, boilers, sawmill machinery, tannery machinery, tanks, smokestacks, and other such manufactured items.

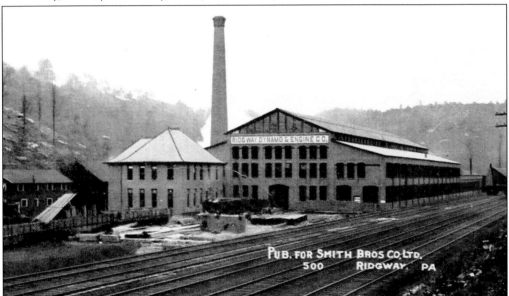

When J. H. M'Ewen left the engine building business for the electrical field, local investors acquired the Ridgway Manufacturing Company and it was renamed the Ridgway Dynamo and Engine Company located along North Broad Street. The business specialized in the production of crank engines and direct current generators. During the 1920s the business experienced financial difficulties. The Ridgway Dynamo and Engine Company passed into the hands of the Elliott Company in 1927. (Glenn Freeburg.)

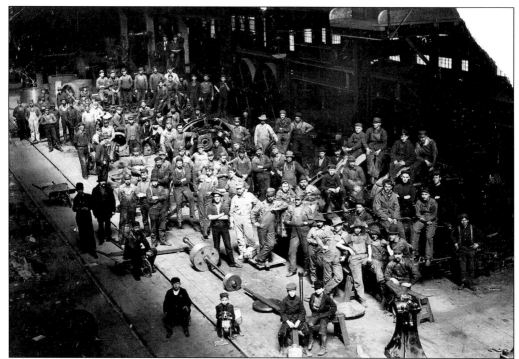

The Ridgway facility of the Elliott Company manufactured electrical propelling machinery for submarines for the U.S. Navy during World War II. Some 1,200 people were employed here during the war, and the company was awarded a citation for its contribution to the war effort. Here is a portion of those workers on the job posing for a group photograph. Note the young boy holding the dog in the front.

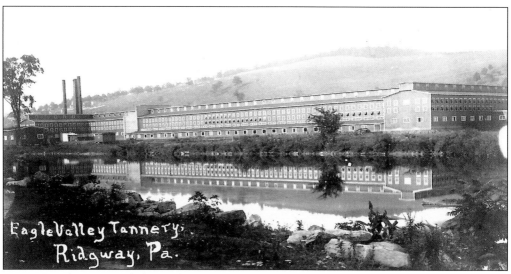

W. H. Osterhout started the Eagle Valley Tannery in Ridgway in 1870. It is shown along the Clarion River during the heyday of the great logging era when it employed 200 men. Tanning was a related industry to timber since it used wood by-products. Hemlock bark was used to tan hides. Large amounts of hemlock bark were needed. The barren hills, shown here, are again forested.

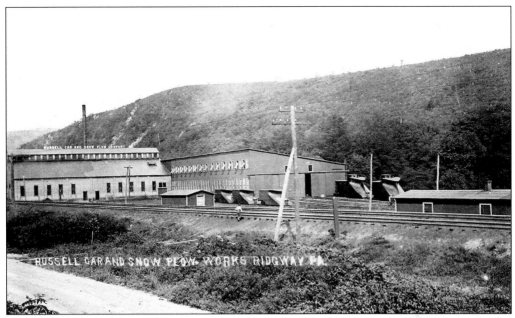

The Russell Car and Snow Plow Company on Front Street in Ridgway manufactured cars for the railroads and also snowplows to clear railroad tracks of snow. Some of the railroad snowplows can be seen outside of the buildings of this industry. The Pennsylvania Railroad, a logical customer, runs past the business.

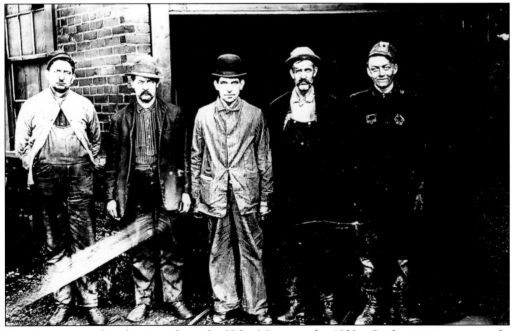

Here is a group of coal miners from the Kyler Mines in the 1930s. Coal mining was a tough, dangerous, and dirty job, and it took a hardy breed of worker to go down into the earth. Safety standards were much lower at that time but the men were proud of their resilience. Note the variety of different styles of work clothes at the time, especially the man in the center with the black bowler hat.

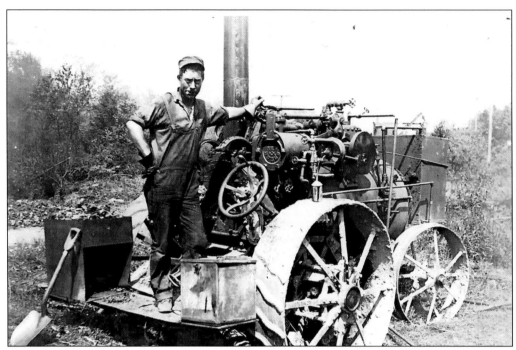

This is a scene from the paving of the Ridgway–St. Marys Road, presently State Route 120. The vehicle was a portable pump used to siphon water out of the nearby creeks to supply the engines and shovels of the road-building machinery. Note the treaded metal wheels. Road building put many men to work during the Depression. (Dave Woods.)

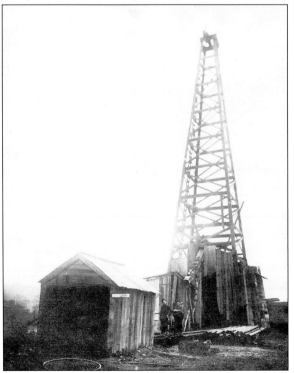

Natural gas fields surround Ridgway. Many of these wells are still operating, especially just west of the town in the Allegheny National Forest. This gas well was drilled by the Hyde-Murphy Company in 1914 to a depth of 2,450 feet at a point opposite of the gristmill. Natural gas was used as a fuel and was readily available.

One farming product that had to be delivered daily before it spoiled was milk. There were many dairies in the Ridgway area and a fleet of horse- or mule-drawn wagons set out at first light to deliver this essential product to area homes. Little boys were always fascinated by the sound of the milk wagon coming.

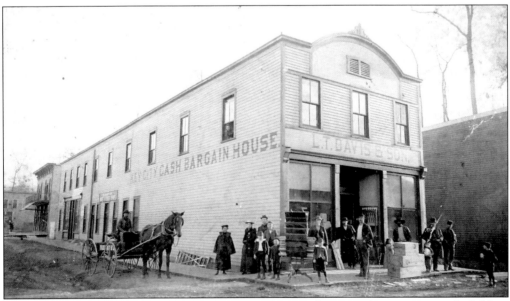

L. T. Davis and Sons Key City Cash Bargain House is shown with customers and children lounging around the storefront. A horse-drawn delivery wagon awaits and crates of items sit on the sidewalk. Note the wooden sidewalks and unpaved streets at this time. A curious woman looks out of an upstairs window.

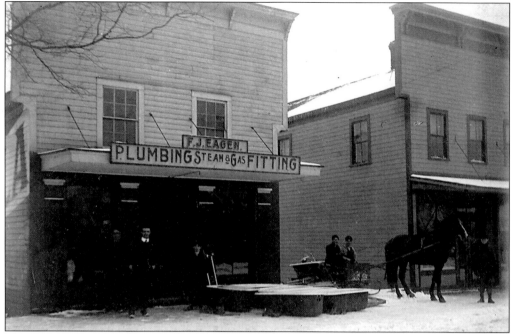

The F. J. Eagen Plumbing, Steam, and Gas Fitting business was located on Main Street in Ridgway. They also sold stoves and ranges. Note that a selection of bathtubs is arrayed in front of the store. They may have just been delivered as a horse-drawn sled is nearby. Some Ridgway winters make sleds as useful as wheeled vehicles.

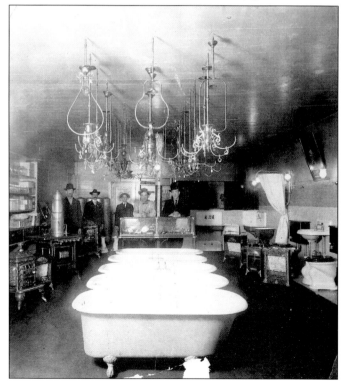

Eagen Hardware was a popular store that carried a wide selection of goods for many years in Ridgway. This scene from inside the store showcases plumbing, lighting, and heating supplies. The store employees are lined up in the background looking on. The store eventually burned. The business was then located on the west side of North Broad Street.

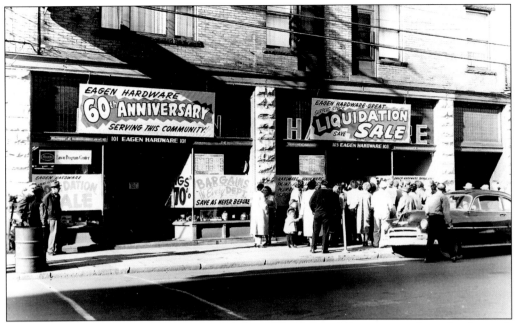

Eagen Hardware was located on the west side of North Broad Street near where the firemen's grounds are today. They were popular with bargain hunters. In this photograph, a crowd has gathered for the 60th anniversary sale in the 1950s. The building eventually burned and was not replaced. Note the old-fashioned litter barrel on the sidewalk.

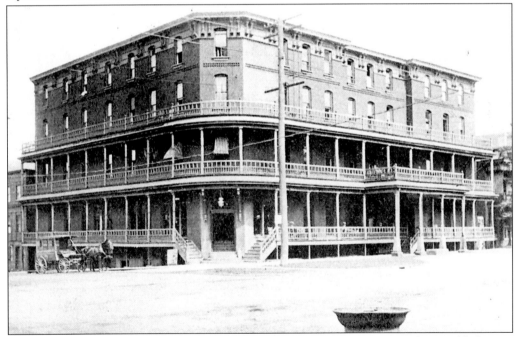

The Hyde House was the grandest of all the hotels in Ridgway's past. Its multi-tiered balconies and ornate cornice gave it an attractive appearance. It stood on the corner of Main and North Broad Streets in the very heart of the town and adjacent to the courthouse. The round object in the foreground is a cistern for horses to drink from. (Tim Leathers.)

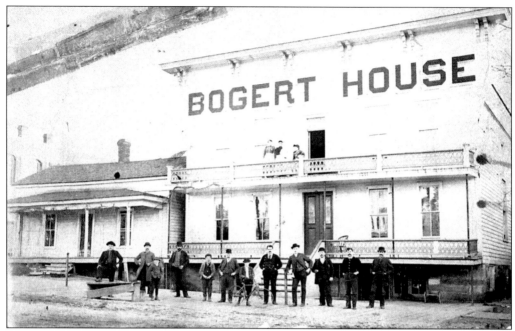

P. F. Bogert started the original Bogert House hotel on the south side of Main Street in 1879. Hugh McGeehin joined the business the next year, becoming sole proprietor in 1886. Elk County's original courthouse was moved here to become the rear section of this building in 1879. It burned in 1990.

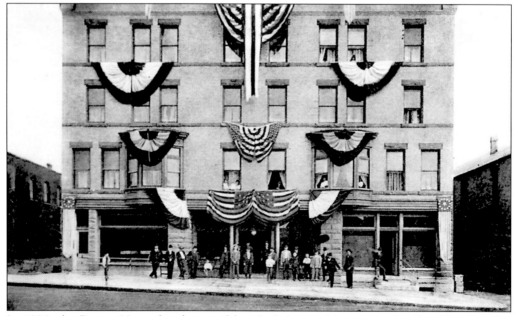

In 1906, the Bogert House hotel, owned by Hugh McGeehin, received a face-lift when the building was fitted with a three-story brick front. It then became known as the New Bogert House. Also added at that time was the first elevator in Elk County. In 1922, Hugh McGeehin's son William McGeehin became the proprietor. Here it is decorated for the International Order of Odd Fellows convention held in Ridgway in 1910. (Mark Wendel.)

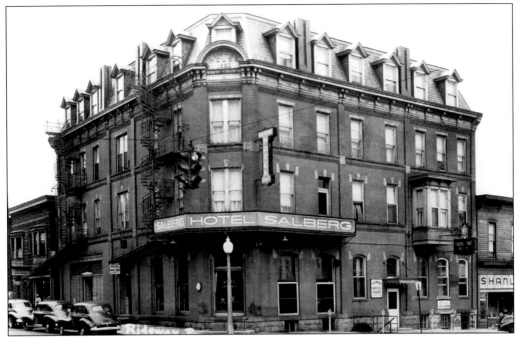

Here is the mansard-roofed Salberg Hotel in the 1940s. It was located on the corner of Main and Mill Streets where the Northwest Savings Bank is today. The hotel had several names over the years. It was built as the Ross House in 1890, changing to the Harris House before the Salberg Hotel. The Shanley dry cleaning and laundry business is on the right. (Tim Leathers.)

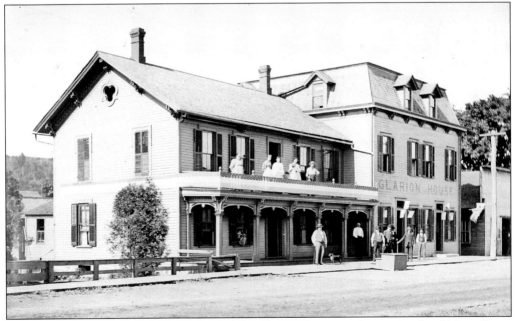

The Clarion House stood on the banks of the Clarion River on the south side of Main Street at the eastern end of the Clarion River Bridge, where True Value Hardware is now. Note the carriage step in front of the hotel and the interesting club shaped window in the eave on the near end. It was also known as the Exchange Hotel and the Bess Hotel at various times.

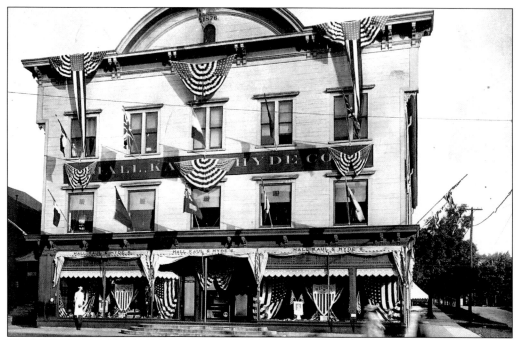

The Hall, Kaul and Hyde Company built this store on Main and South Broad Streets in 1876. The business was owned by father and son businessmen J. S. Hyde and W. H. Hyde. Later J. K. P. Hall and Andrew Kaul joined the business. This store was reputed to be the largest of its kind in western Pennsylvania. The store is shown decorated for the welcome home celebration of World War I.

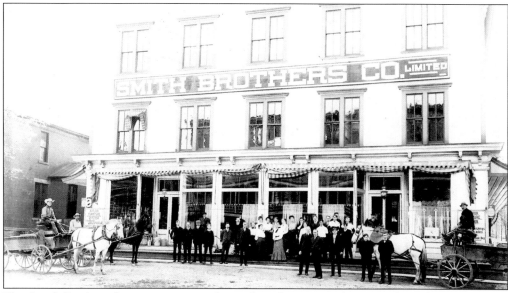

The Smith Brothers Company store was located on the corner of Main and South Broad Streets across from the courthouse. Smith Brothers was a chain of department stores that had several locations in the area, including St. Marys and Wilcox. The building was originally the Hall, Kaul and Hyde Company store. The horses and wagons in the street give Ridgway the appearance of a frontier western town in this photograph.

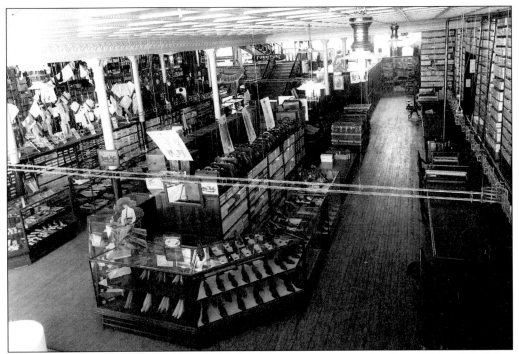

The shoe department of the Smith Brothers Company new store in the Grand Central Building is shown. The Smith Brothers Company was eventually taken over by the G. C. Murphy Company chain of department stores. The business eventually connected onto North Broad Street through what is today the Clarion River Trading Company.

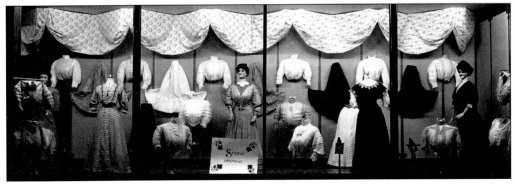

The Smith Brothers Company new store is shown. This was after the business moved into their new location in the Grand Central Building on Main Street. This is a scene of the display windows in the cloak department. The ladies of Ridgway eagerly awaited the arrival of the spring fashion line.

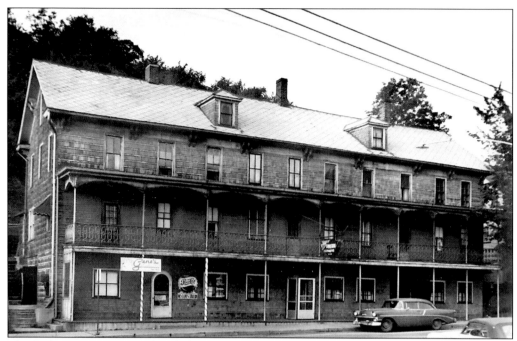

The Ridgway House was a hotel that catered to trainmen located on Front Street near Depot Street. The original Pennsylvania Railroad's passenger station was just across the street. In 1890, Fred Herrman bought the building and operated a tavern here commonly called Herman's for many years. The bar was also known as McCoy's, the R&J, and the Mad Dog Saloon at various times. The building was eventually torn down.

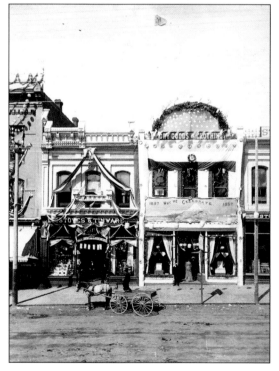

The Vining Brothers and Company tin shop was celebrating its 30th anniversary on Ridgway's Main Street in 1887 in this photograph. They handled stoves, tinware, plumbing, gas fitting, dry goods, and clothing. Flags, bunting, and banners announce the event to prospective customers as the delivery wagon and horse patiently wait.

The Salberg Grist Mill was located along Elk Creek where the Lyle G. Hall Park is today. The mill was originally built by Enos Gillis in 1824. The grinding of the area farmers' grain was an integral part of the survival of man and beast during the early life of a community's growth. (Lawrence Buehler.)

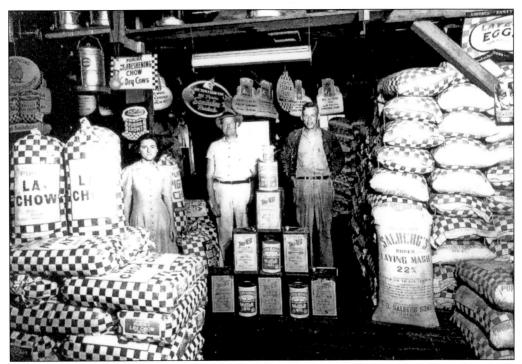

South Mill Street and Race Street on Elk Creek are both named after the Salberg Grist Mill, which operated for many years grinding grain and selling feed for cows, horses, chickens, and other livestock. Shown are the employees with many bags of these products. Most of the first settlers planned on being farmers before turning to the extraction of natural resources.

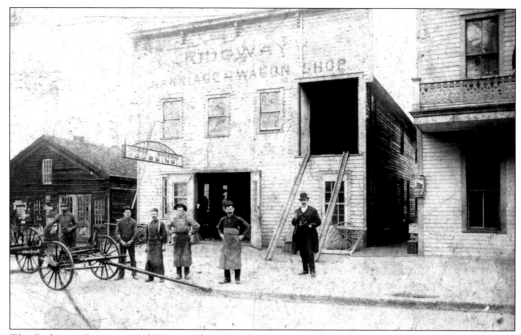

The Ridgway Carriage and Wagon Shop was located on the north side of Main Street's west end beside the McFarlin House hotel, which is visible on the right of this photograph. Building and maintaining carriages was a big business before automobiles. Note the ramps on the right side of the building used to lower carriages to the street that have been serviced on the second floor.

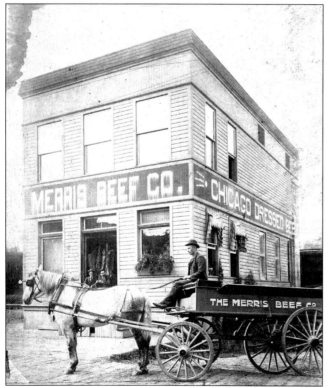

The Merris Beef Company was located on North Broad Street across from the Pennsylvania Railroad station. The business was established in 1892 as the Ridgway Beef Company and later the Pennsylvania Beef Company. The business handled products from the Armour Meat Packing Company of Chicago, Illinois. The company's delivery wagon is shown. Note that through the doorway, beef carcasses can be seen hanging in the open air.

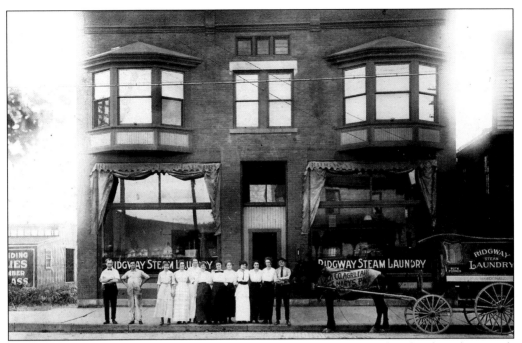

The employees of the Ridgway Steam Laundry on North Broad Street are lined up for a photograph with their delivery wagon and faithful horse. This was the first steam laundry between Erie and Philadelphia. When the building burned in 1901, the business was rebuilt using more modern equipment. In 1949, the building became a beer distributorship.

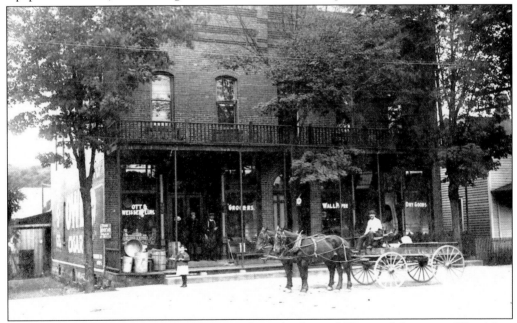

This building still stands in West Ridgway and was the Ott and Weissenfluh store on West Main Street. It sold groceries and dry goods. It was later known as the Thompson Store. The delivery wagon is parked in front of the business and on the left side of the building they are advertising 5¢ cigars.

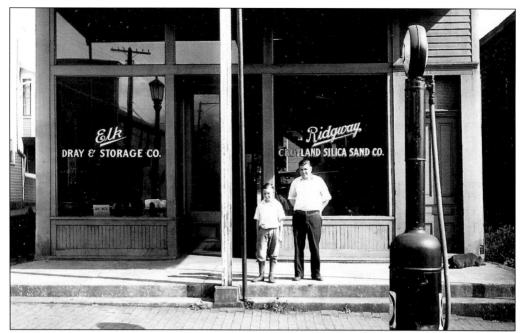

Joseph Urmann Sr. and Joseph Urmann Jr. are seen in front on the Ridgway Croyland Silica Sand Company and the Elk Dray and Storage Company. Note that the street was paved with bricks at that time and the old-fashioned gas pump in front of the building. A sign advertising the Ridgway Boosters is in the window.

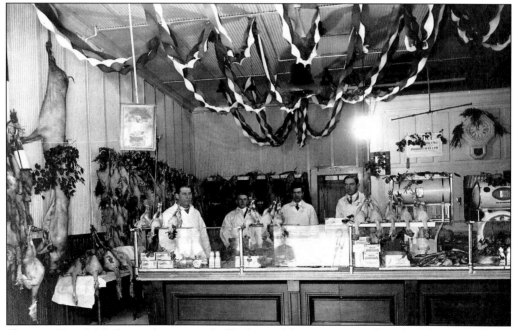

Shown is Dean's Market in the west end of Ridgway. Many carcasses of butchered pigs, chickens, and other fowl can be seen hanging in the open, unrefrigerated air. Food laws are different today, but this was a more relaxed time. However, it appears that neckties were part of the dress code. It appears to be around the holidays because there are so many turkeys or geese for sale.

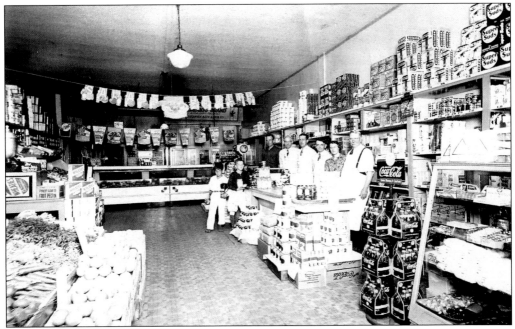

Here is slightly more modern scene from Dean's Market in the west end. This was a busy little market at times as can be attested to by the fact that six employees are lined up to wait on customers although they can only cater to two young boys at the moment. Some of the products available are Coca-Cola, Wheaties, Heinz pickles, Bisquick, Super Suds, and fruit pectin.

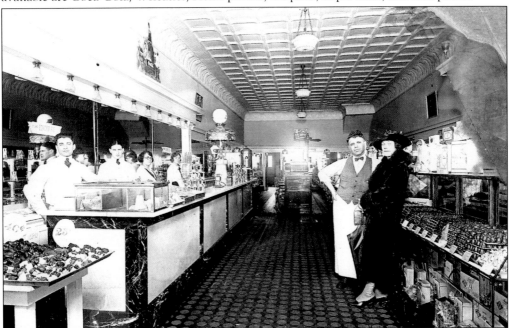

The Candy Kitchen was a fixture on Main Street in Ridgway for many years. A lot of candy was sold from this establishment, as evidenced by the fact that they have five employees on duty ready to serve customers and a wide assortment of samples can be seen in this photograph. An elegant fur-coated lady is about to indulge her sweet tooth. The sign says Eskimo Pies are available.

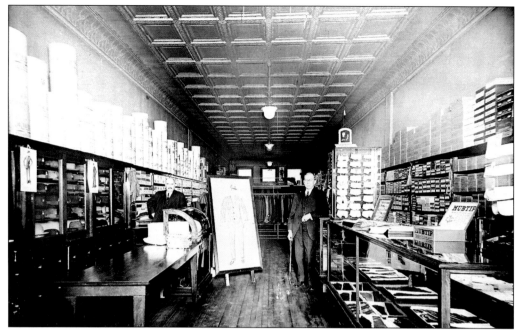

Parshall Brothers haberdashery on Main Street in Ridgway is shown in 1909. Note the fitting diagram board and the various hatboxes, suits, socks, neck collars, and neckties. The two clerks appear to be dressed fashionably, as one would expect in their line of work. Note the pressed tin ceiling in this building.

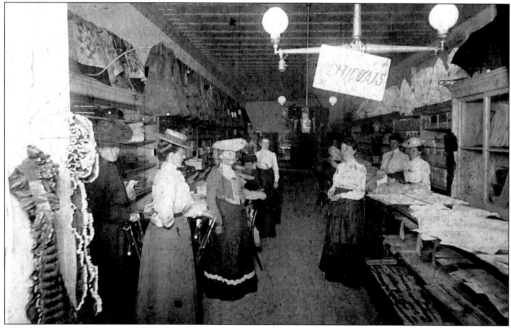

This is a scene inside Hugh McGeehin's store on Main Street in Ridgway. McGeehin started out as a pack peddler in northwestern Pennsylvania before opening a store in Ridgway. He also operated the Bogert Hotel. His store appears to be a magnet of feminine style in Ridgway as these ladies are choosing from a large selection of finery in this fashion emporium.

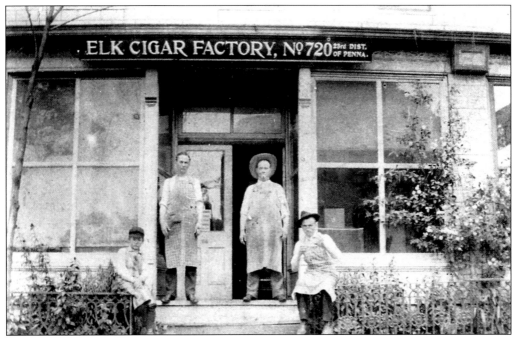

The Elk Cigar Factory was located on North Mill Street in Ridgway. E. D. Avery was the proprietor. Hand-rolled cigar production was a highly skilled occupation and cigar makers were an early industry to be unionized. Cigars were more popular than cigarettes before the introduction of the cigarette rolling machine and mass production.

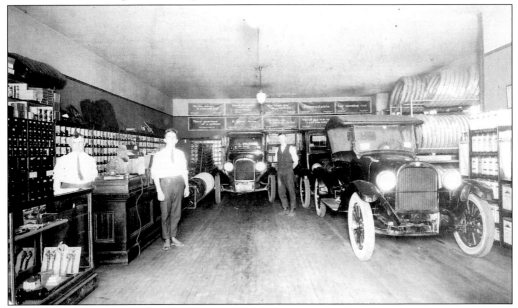

The interior of a modern new car showroom has much the same ingredients as here, but the look is much different since automobiles are the epitome of change in fashion and style. These early vehicles look very dated. On the wall are rows of spare tires since early roads were notoriously rough. Later enormous picture windows were added to allow passersby to see the product without actually entering the showroom.

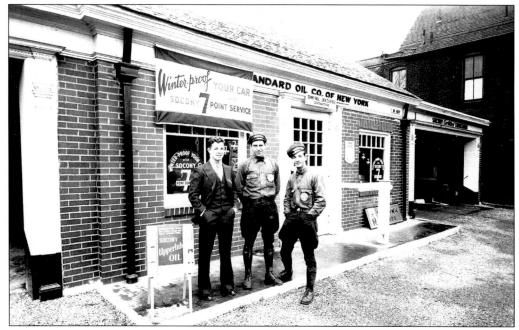

Tom, Paul, and Jack Clifford are seen standing in front of their service station, which was located on North Broad Street where the Sheetz store is today. It seems quaint today, but many service station attendants in the past used to wear uniforms like these men in fancy caps and jodhpurs. They also checked the oil, tire pressure, and cleaned the windshield, all luxuries of the past.

Ridgway Power and Light employees are posing for a photograph in a studio setting, possibly for publicity or advertising. Electric workers had to be trained to work with potentially hazardous situations. Note the hand axe hanging from the man on the left. The man on the right is wearing a vest and tie.

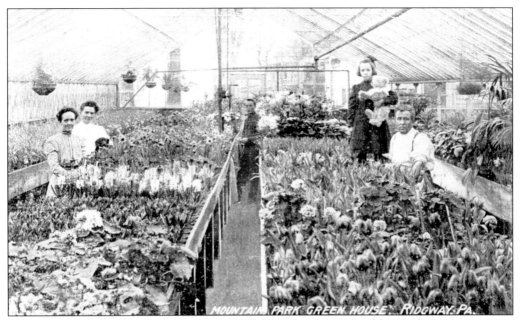

This is an interior view of the Mountain Park Greenhouse operated by Hugh Girton on West Main Street in Ridgway. Girton is on the right with his daughter holding a teddy bear. Other employees are shown, one holding a dog. It is around Easter time because Easter lilies, hyacinths, and other spring flowers are evident. (Glenn Freeburg.)

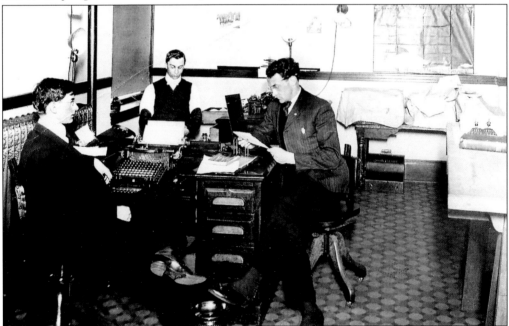

This is the inside of the Russell Car and Snow Plow Company. The business made railroad cars and snowplows for trains. Seated at right is manager Dan Dickinson, grandson of lumber pioneer George Dickinson. Note the several items that are obsolete in this photograph. The men are using adding machines and typewriters. Dickinson is wearing spats and there is a spittoon on the floor. (Tim Leathers.)

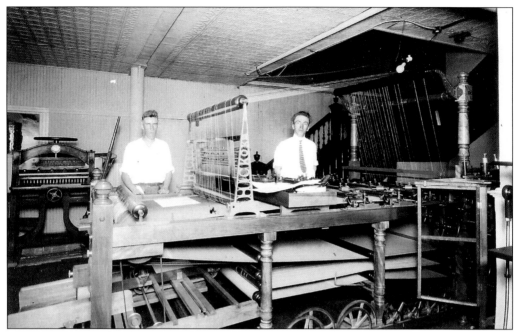

Here is a view inside Clayton Crawford's Print Shop in Ridgway. Printing machines were large, complicated devices full of wheels and wires. Printers needed to be mechanics to keep the apparatus functioning. Technology has transformed this business and it is much different today. Computers have automated much of the process used in the printing business.

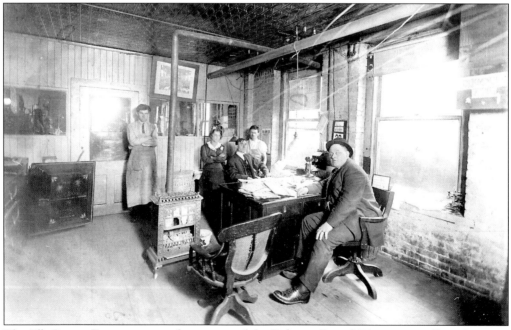

The *Elk County Democrat* was a forerunner of the *Ridgway Record*. Typewriters allowed women to get out into the workforce, where it was eventually found that females could also do the jobs that men could do, a closely guarded secret for centuries. The presence of the woman in this newsroom as they prepare to get out the news was a harbinger of things to come.

Two
BUILDING A COMMUNITY

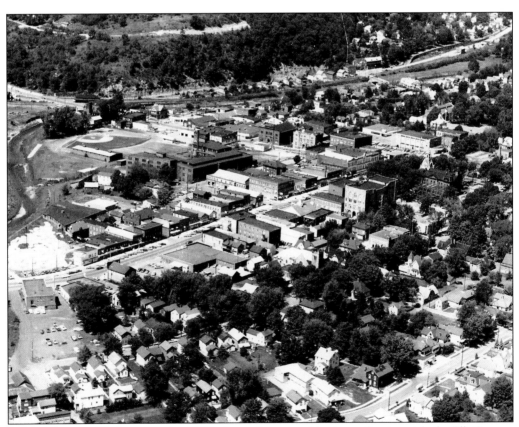

An aerial view of Ridgway in the 1960s shows the central business district with the Elk County Courthouse tower, upper right, along Main Street cutting diagonally across the scene. Elk Creek is on the upper left beside the baseball field on North Broad Street. The Pennsylvania Railroad cuts across the top of the photograph. Their station is upper left. The Hyde-Murphy Company is beyond the outfield of the baseball field.

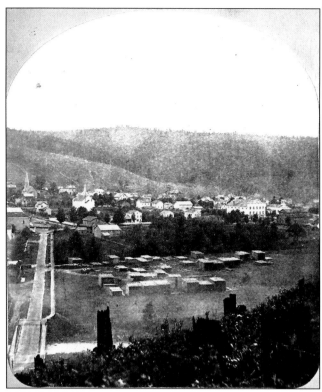

This is an early view of Ridgway taken from Hyde Hill along Front Street near the present high school. The Hall, Kaul and Hyde Department Store is the large white building at the right of the photograph. The Ridgway Welcome Center is located here today. Just to the right of that, the original county courthouse is visible. Note the piles of lumber along Elk Creek in the foreground. (Glenn Freeburg.)

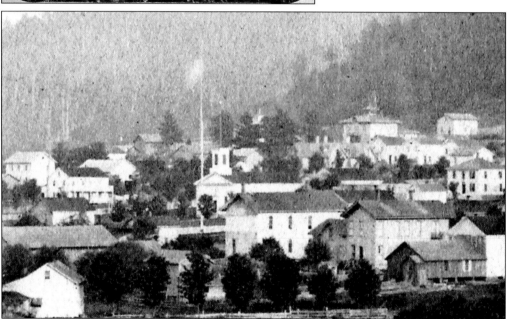

The first Elk County Courthouse is the building with the tower and the large flag in front of it in downtown Ridgway. It was completed in 1845. Very few photographs of the first courthouse exist, and most of these wood frame buildings are gone today. However, the Jerome Powell residence, which is the Victorian Towers Bed-and-Breakfast today, is the large, square building in the upper right.

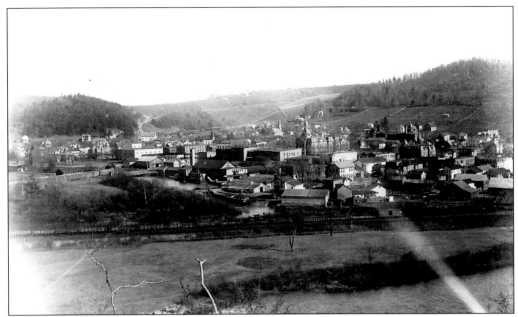

This view of Ridgway was taken from the Ridge Avenue vicinity. It shows the Elk County Courthouse prominent downtown and the rear of the commercial buildings on Main Street across from the courthouse. The Salberg Grist Mill is seen along Elk Creek. The last street behind the courthouse was called Out Street because it was the furthest street out—today it is South Street.

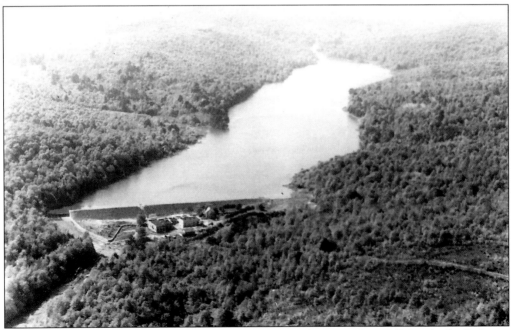

This is a view of the Ridgway Water Authority's impoundment on Big Mill Creek, the Ridgway Reservoir. The area around Ridgway is still mostly forested. After the great logging boom when many areas were clear-cut, the mountains have regenerated a new crop of renewable timber. The reservoir is a popular place for fishing and bird-watching.

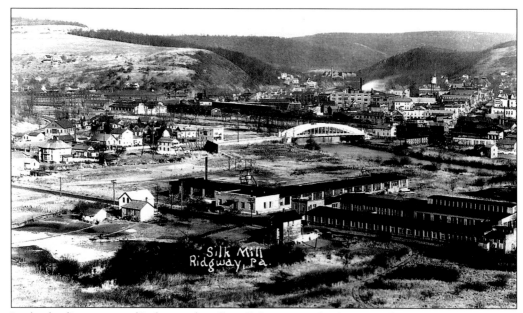

In this bird's-eye view of Ridgway, the silk mill dominates the foreground. Prominent at center is Will Dickinson's bridge carrying Main Street over the Clarion River, built in 1915. In the upper right is the water tank that was part of the Hyde-Murphy Company. The view is north, looking up the Clarion River Valley. (Tim Leathers.)

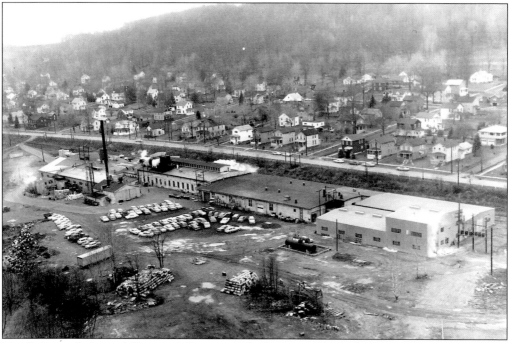

The Ridgway Color and Chemical Company, also known as the "Ink Plant," is seen in this aerial view of East Ridgway from 1940. Front Street (Route 120) bisects the photograph. The business employed many area workers as evidenced by the number of cars in the parking lot. Hyde's Hill is in the background.

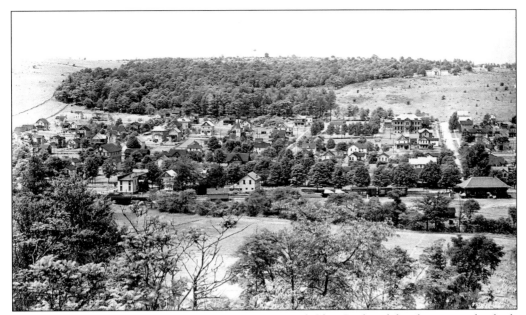

Here is West Ridgway from the air. The Baltimore and Ohio Railroad freight terminal, which eventually burned, is seen at the lower right by the train tracks. In the right center is the Walnut Street School and in the upper right, in Pine Grove Cemetery, the Sarah Thayer mausoleum is visible.

The houses in this scene are on the west end of Upper Front Street in Ridgway. The highway bisecting the photograph is Front Street (the St. Marys Road) and below that are the Pennsylvania Railroad tracks. Construction is underway at the site. In 1936, a stone wall was built by the Works Progress Administration to stabilize the bank below Front Street.

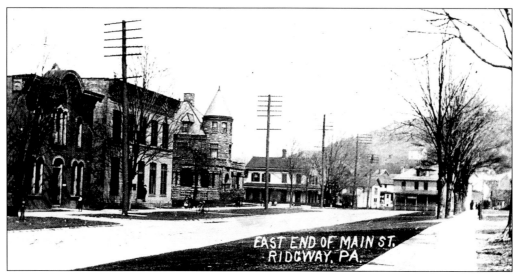

This scene is looking east on Main Street in Ridgway. The buildings, from left to right, are the Hall Office Building, the Ridgway Tannery offices, the McCauley/Murphy mansion, the Harry Alvan Hall residence (originally the Gallagher home), and at the end of the street the old Ridgway Masonic Temple. (Glenn Freeburg.)

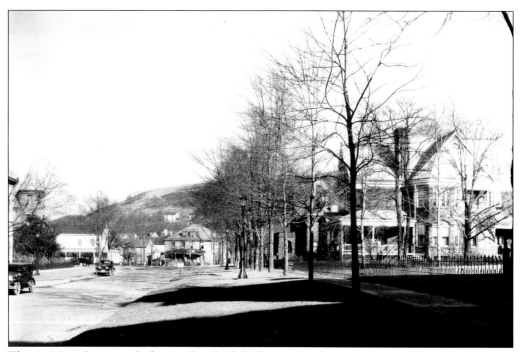

This is Main Street in Ridgway. On the left the turret of the McCauley/Murphy mansion is visible. The white building on the left side of the street is the Harry Alvan Hall residence (originally the Gallagher house). At the end of the street is the original Ridgway Masonic Temple. On the right side of the street is the J. K. P. Hall mansion, currently occupied by the American Legion.

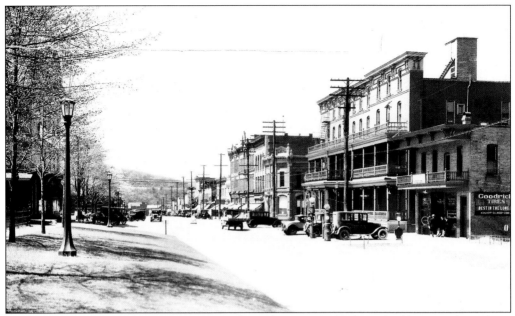

This is a scene on Ridgway's Main Street from the 1930s. The large building on the right is the Hyde House, the prominent landmark hotel located at the intersection of Ridgway's two busiest streets. Note the gasoline pumps in the street in front of the hotel and the traffic signal in the middle of Main Street. Ridgway's broad thoroughfares have always given the town a spacious look.

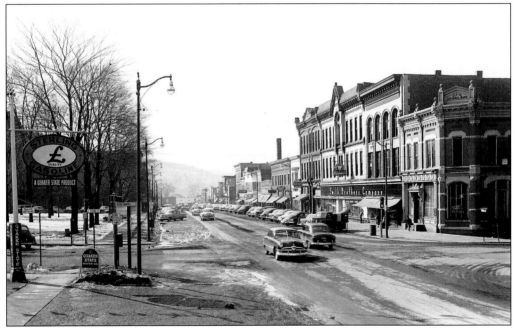

This is a view of Main Street in the 1950s. It is winter and there is a light dusting of snow on the ground. On the left is the Court Service Station selling Sterling Gasoline and Quaker State Motor Oil products. On the right is the Elk County National Bank, built in 1889, and to its left is the Smith Brothers Company, after they had expanded into the Grand Central Building.

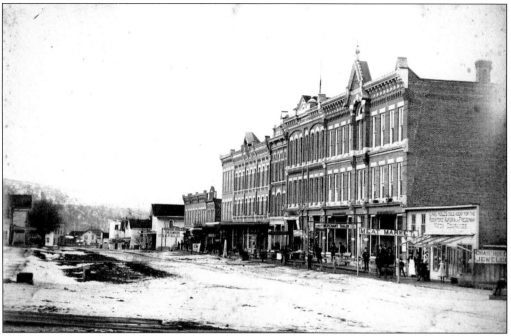

This is an early view of Ridgway's Main Street before the 1910 fire changed the skyline forever. Note the wooden planks for pedestrians to avoid the muddy sections of Main Street. Businesses visible are a dining hall, a merchant tailor, a meat market, and a jeweler. The historic architectural character of the surviving buildings has been preserved and restored and once again reflects the grandeur of the past.

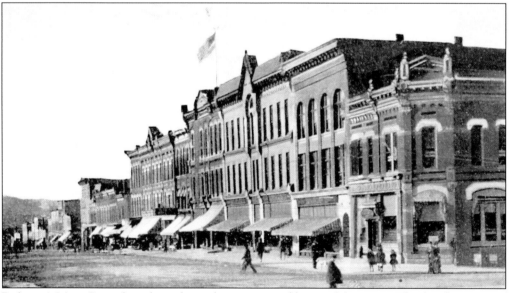

Ridgway's Main Street has always been the commercial heart of the town. This bustling view of Main Street with all of the shops sporting awnings to shade the many shoppers is from before the Hyde-Murphy Company fire in 1910 and shows the imposing architecture and cornices of the prefire Ridgway. Several buildings to the left of the building with the flag were destroyed by that conflagration. (Glenn Freeburg.)

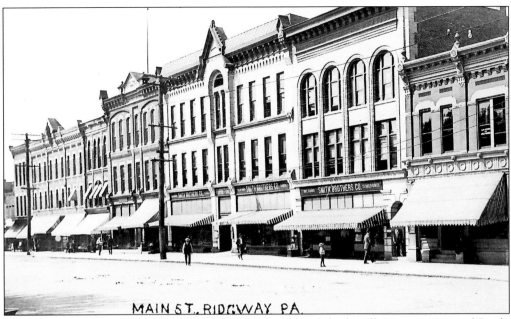

Buildings on Ridgway's Main Street include, from right to left, the Elk County National Bank, the Smith Brothers Company with its new facade, the Smith Brothers addition in the Grand Central Building, and the Schoening and Maginnis Union Hall. The Hyde-Murphy Company fire of 1910 destroyed all of the buildings to the left of that. (Dave Woods.)

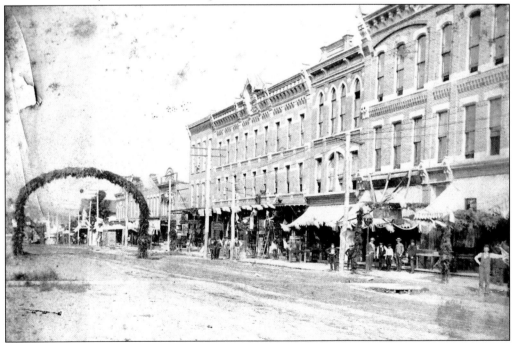

This view of Main Street in Ridgway shows the 1886 Fourth of July decorative arch and the pre-1910 skyline of Main Street before the Hyde-Murphy Company fire destroyed several buildings in this block. Note that everyone in the scene is looking at the photographer including the man on the awning and the man standing on top of the stepladder.

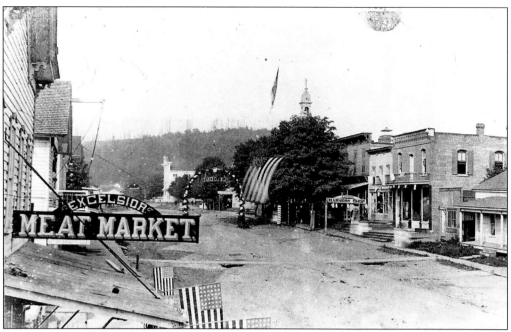

Old Glory waves in the breeze on a wire across Ridgway's Main Street on the Fourth of July in 1886. Arches of hemlock boughs adorn both ends of Main Street. The Elk County Courthouse tower is visible above the trees. The white building at the end of the street is the Hall, Kaul and Hyde Store. Other businesses visible are the Excelsior Meat Market and F. Schirk's Harness Shop.

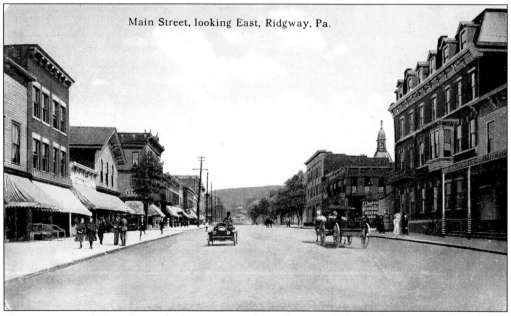

Here is a view of Main Street looking east in the early part of the 20th century. Horse-drawn wagons share the wide street with early-model automobiles. In this view, the Salberg Hotel is on the right of the photograph. Also note the Elk County Courthouse tower at right, center. (Glenn Freeburg.)

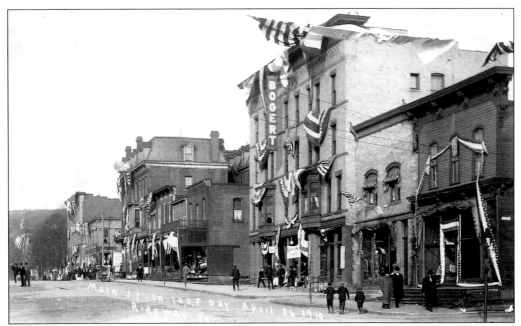

Ridgway is decorated for the International Order of Odd Fellows convention on April 26, 1910, three days after the huge Hyde-Murphy Company fire. The three largest buildings are, from right to left, the New Bogert House, with large flag; the Salberg Hotel, with mansard roof; and the Ridgway National Bank.

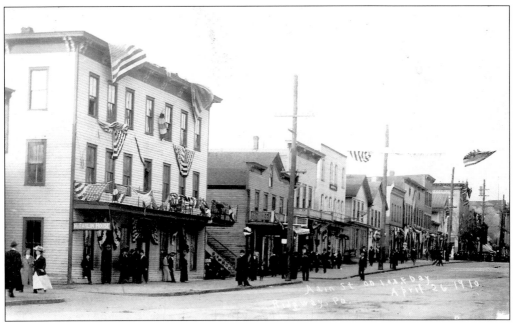

The International Order of Odd Fellows convention and parade is the occasion. The town is decorated with flags and patriotic bunting. Many of these pedestrians are sightseers to the biggest fire in Ridgway's history. The Hyde-Murphy Company fire ruins are still smoldering down Main Street at the right in this scene. The McFarlin House hotel is at the left.

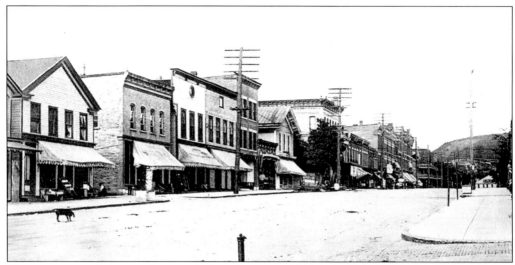

This is a view of the north side of Main Street in 1905 before the Hyde-Murphy Company fire caused several of the buildings on the far right to be destroyed. The streets are paved with brick at the time. There does not seem to be much traffic, and dogs loiter in the streets without much bother.

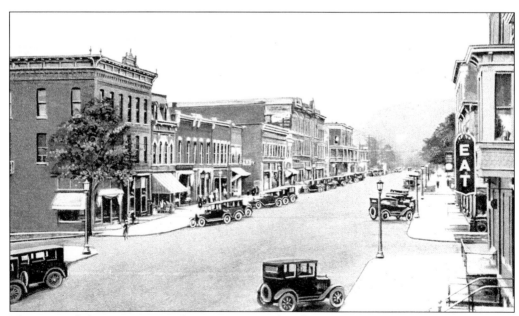

This view of the intersection of Main Street and Mill Avenue was taken from the Shanley Building. The EAT sign is on the Salberg Hotel. The large building on the left corner is the Ridgway Drug Company building. The scene is from after 1910, since the buildings in the center have been rebuilt after the Hyde-Murphy Company fire. (Glenn Freeburg.)

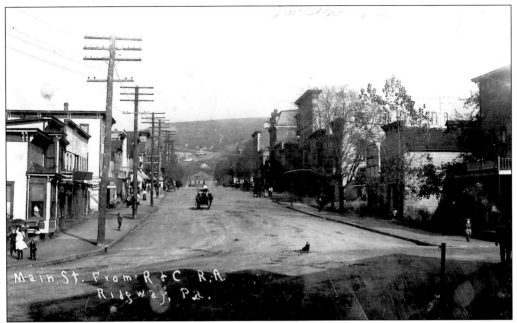

This view is looking east on Main Street from the west end of town. The large white building on the left side of the street is the McFarlin House, later the Larson Hotel, and the Bogert House is visible on the right side of the street. Note the horse cart on Main Street and the chicken pecking in the middle of Main Street in this early view.

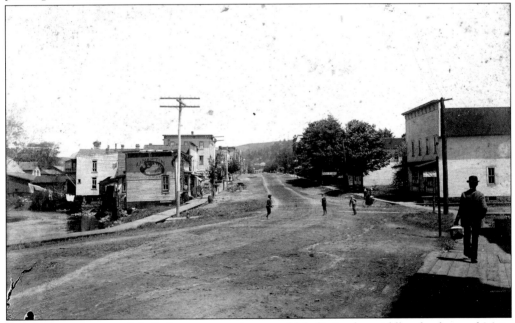

In 1896, in pre-automobile Ridgway, young boys could frolic in the middle of a deserted Main Street without interruption. This view, looking east from the Elk Avenue intersection, shows a lone gentleman in a bowler hat strolling down the wooden sidewalk with a picnic basket to meet his date. Note the clothes on the wash line on the left. Businesses visible are photographer A. A. Martin, McGloin's Restaurant, and the Irish Store.

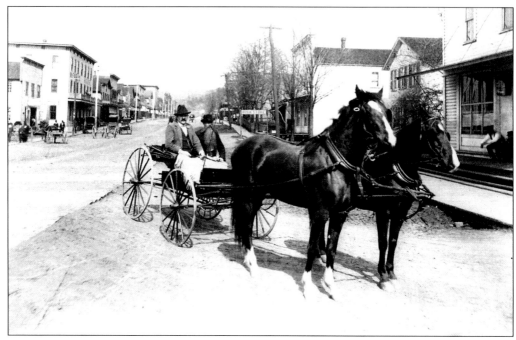

Early in the last century, before the arrival of automobiles, Mike O'Connor and J. "Whiskers" Olson are shown in Hugh McGeehin's buggy at the corner of Main Street and Elk Avenue. Behind them on Main Street are the McFarlin House on the left and the Irish Store on the right. Note the wooden sidewalks.

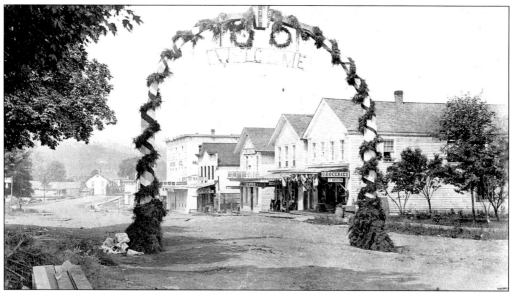

This decorative arch graced the west end of Ridgway's unpaved Main Street for the Fourth of July celebration in 1886. Just inside the arch on the left is the McFarlin Hotel and just inside the arch on the right side is Tom Noon's grocery store, which served as the recruiting station in Ridgway for the Civil War. In the very center is a harness shop, a necessity in pre-automobile Ridgway.

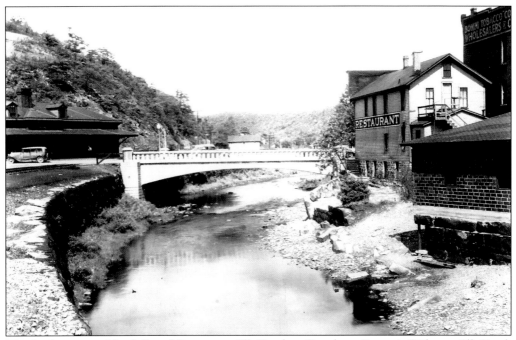

This bridge carries North Broad Street over Elk Creek at Osterhout Street in Ridgway. Elk Creek flows into the Clarion River just below this site. In the left of the photograph is the Pennsylvania Railroad passenger station, built in 1907. On the right is the Pennsy Restaurant, which opened in 1911 and is still in business. This scene dates from 1936.

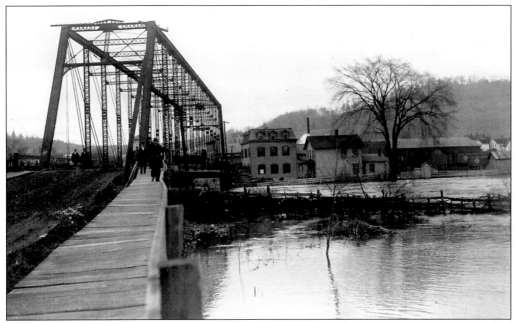

Ridgway is located on the Clarion River and has been spanned by six bridges in the west end of town at Main Street. The first bridge was a toll bridge and had a toll collector's house nearby. This metal bridge with a wooden sidewalk is shown at high water. The building at the end of the bridge was the Exchange Hotel and is located where True Value Hardware is today.

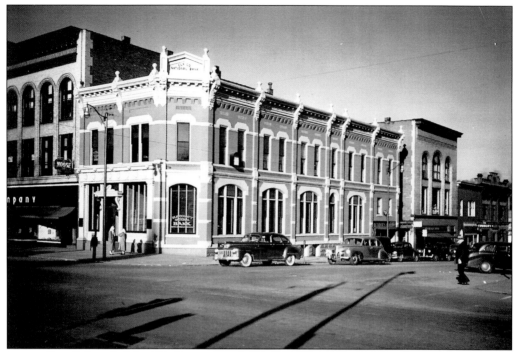

Jerome Powell founded the Elk County National Bank in 1874. Their new ornate building was begun on the corner of Main and North Broad Streets in 1889. The buildings on either side were occupied by the Smith Brothers Company and once connected in the back. The building on the right is now the Clarion River Trading Company.

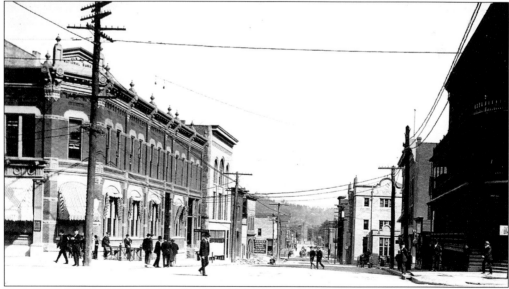

This is the intersection of North Broad Street and Main Street in Ridgway. The buildings from left to right are the Elk County National Bank, the Broad Street addition to the Smith Brothers Company Department Store, and across the street, the YMCA, the Lepsch-Gardner Building, and the Hyde House. Note that traffic signals at Ridgway's main intersection are, as yet, unneeded.

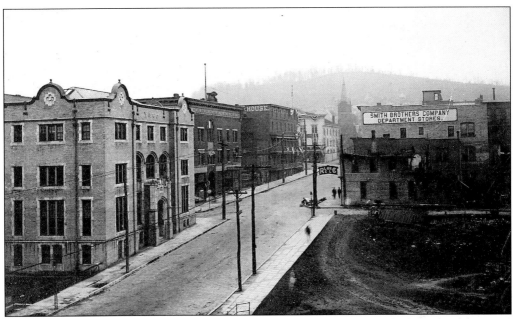

This is North Broad Street in Ridgway, looking south. The buildings on the left side of the street are, from left to right, the YMCA, the Lepsch-Gardner Building, the Hyde House, and across Main Street, the Clawson and Fisk Store and the Trinity Methodist Church. On the right side of the street is the Smith Brothers addition, and, in front of that, the charred remains of the first wooden Ridgway Light and Heat Building.

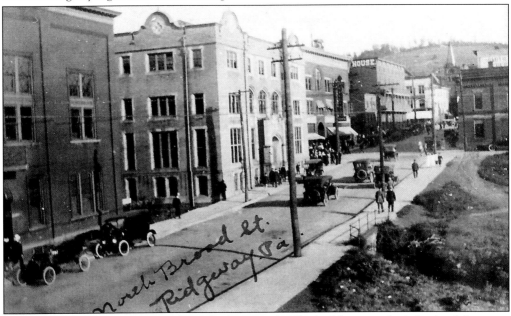

This is North Broad Street in Ridgway looking south. The buildings on the left side of the street from left to right are the Ridgway Armory, the YMCA, the Lepsch-Gardner Building, the Hyde House hotel, and across Main Street, the Smith Brothers Company Department Store. On the right side of the street is the new brick Ridgway Light and Heat Building. Also visible is the steeple of the Trinity Methodist Church. (Glenn Freeburg.)

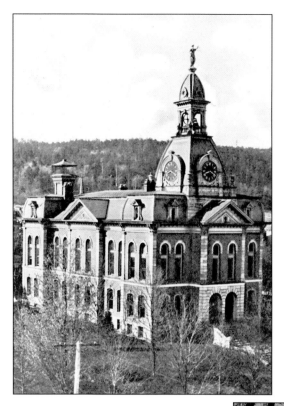

The present Elk County Courthouse has three stories with a mansard roof surmounted by an ornate, slate-covered tower. The tower included a nine-foot diameter clock, a 1,000-pound steel bell, and a nine-and-a-half-foot zinc statue of the goddess of justice. The courthouse is approached by a grand staircase. Today the grounds are accented with lampposts, cannons, and stately trees. (Glenn Freeburg.)

The distinctive tower of the Elk County Courthouse has been a landmark in Ridgway since the building was completed in 1880. It included a nine-and-a-half-foot statue of the goddess of justice brandishing a three-foot sword and covered in gold leaf sparkling in the sun. The statue was struck by lightning, removed, and replaced by a weather vane. The slate-roofed tower is still quite impressive. (Dennis McGeehan.)

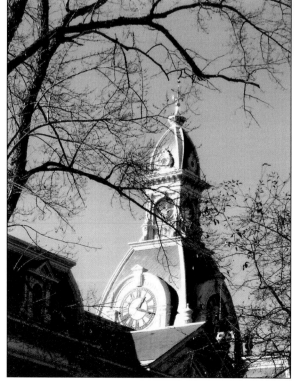

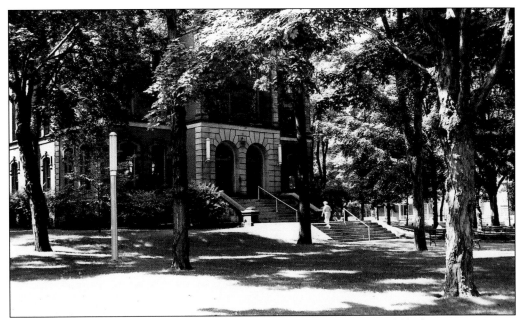

The Elk County Courthouse in Ridgway sits on a beautifully landscaped block on Main Street. The grounds include a gazebo, decorative cannons, and park benches, making it a perfect place to rest and observe the typical main street of small-town American life. Large, leafy trees shade the space. Seedlings from the maple trees that were planted on the Gillis farm, where the town of Ridgway started, were transplanted here.

The beautifully landscaped grounds of the Elk County Courthouse are a good place for a quiet stroll, either during the hot summer months beneath the tall majestic trees or after a winter front has turned the trees into works of delicate white, winter sculpture. Here a hardy hiker has stopped at the courthouse with his faithful walking companion to contemplate the timeless beauty of the season.

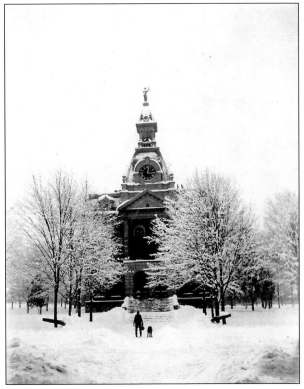

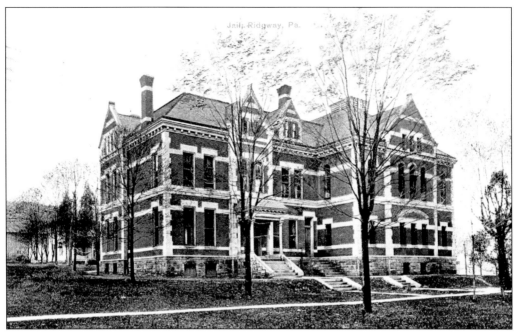

This Elk County Jail, built in 1884, replaced an earlier stone structure built in 1848. The director of the project was M. V. Van Etten with D. K. Dean as the architect. A room in the Elk County Courthouse was used as a jail during completion. In 1964, the building was damaged by a fire set by an inmate, and in 1966, the building was remodeled. (Dave Woods.)

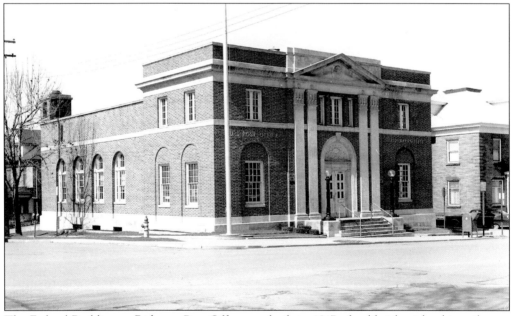

The Federal Building or Ridgway Post Office was built in 1917 of red brick with white pilasters supporting a Greek-style pediment on the corner of South Mill Avenue and Center Street. The Ridgway Post Office had been located in several different buildings on Main Street, including a period when it was located on the ground floor of the Ridgway National Bank Building at Main and Court Streets.

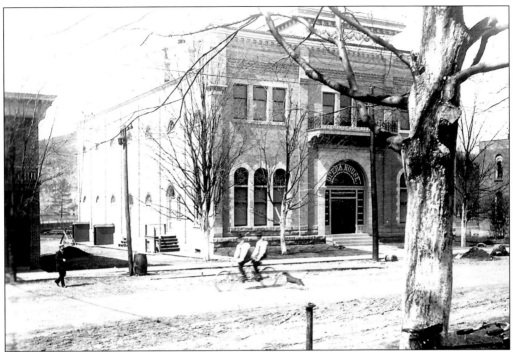

When the Ridgway Opera House opened on April 20, 1897, special trains from DuBois, Falls Creek, Brockway, Kane, Johnsonburg, and St. Marys delivered a capacity crowd to opening night. In this c. 1900 view, nattily dressed wheelmen on a bicycle built for two pedal past the grand palace with a street dog yapping at their heels.

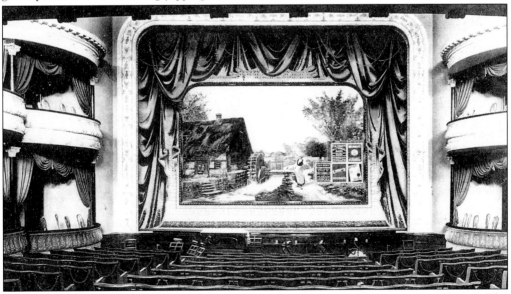

The Hyde-Murphy Company built the Ridgway Opera House in 1896 on Main Street. The architects were Walter P. Murphy and H. C. Park. It seated 1,163 persons for performances. It had a 40-by-66-foot stage, loge seating, beautiful draperies, and an orchestra with an elegant piano. The total cost of the building was $50,000, and it was an area showcase for several years before burning. (Glenn Freeburg.)

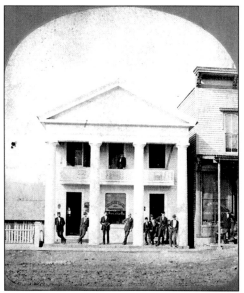

This is the first bank building in Elk County. Built during the Civil War, it stood on the north side of Main Street across from the courthouse. The building burned in 1882. The bank was started by Henry Souther, who came to Elk County to cut timber. He came to Ridgway from Boston, Massachusetts, about 1839. Eventually Souther became a lawyer, treasurer of Elk County, and district attorney. (Glenn Freeburg.)

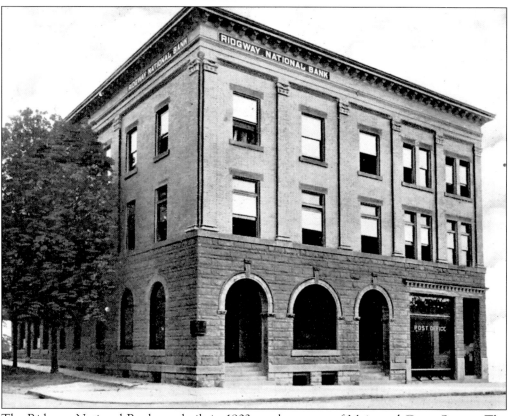

The Ridgway National Bank was built in 1903 on the corner of Main and Court Streets. The builder was M. V. Van Etten of Warren, who had also built the Elk County Jail. This business eventually moved up the street to Court and Center Streets and the building today is known as the Anderson and Kime Building. Note that the Ridgway Post Office was located on the ground floor, right. (Glenn Freeburg.)

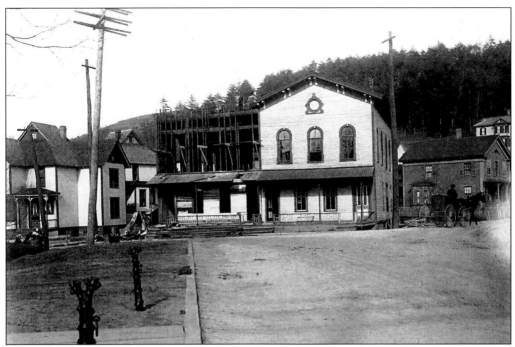

Shown is the dismantling of the first wooden Ridgway Masonic Temple at the foot of Boot Jack Hill on East Main Street. A buff brick building, which still stands, replaced it. On the right is the Minor Wilcox House, one of the earliest homes still standing in Ridgway. Note in the left foreground the tree-stump shaped, cast iron hitching posts in front of the Calvin McCauley mansion.

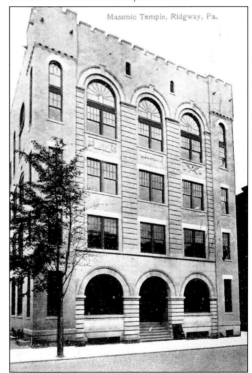

This is the Ridgway Masonic Temple on Court Street across the street from the Elk County Courthouse. It is an imposing white edifice, which is a prominent downtown landmark. Over the years, it has held many tenants besides the Masons. The United Mine Workers and numerous lawyers' offices have shared the space. The art deco building is emblazoned with Masonic symbols. (Glenn Freeburg.)

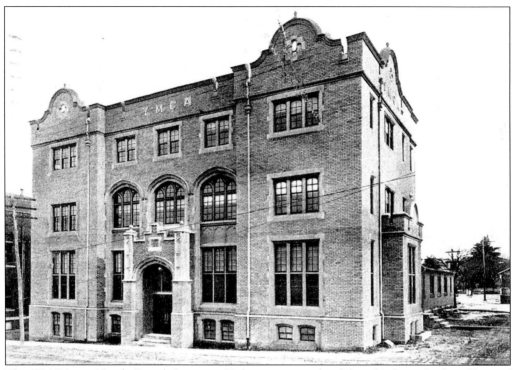

The YMCA on North Broad Street in Ridgway was realized largely through the efforts of Dr. W. M. Pierce, superintendent of the Ridgway Borough Schools. When the building was constructed, it included a gymnasium and eventually a swimming pool. The YMCA was used for classes, lectures, and theatrical and musical performances. It has long been at the center of Ridgway's social life. (Glenn Freeburg.)

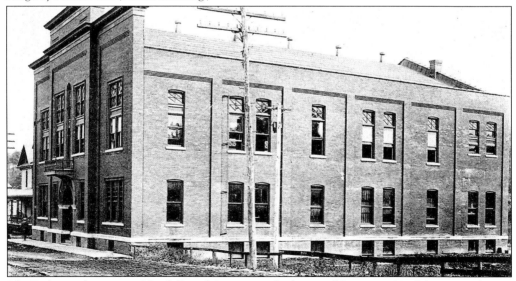

The Ridgway Armory on North Broad Street was the home of Company H of the Pennsylvania National Guard and is still used by the National Guard. The second-floor drill hall was also the scene of fancy balls and dances over the years. The building was once the home of the Elks Club. The armory has had at times a restaurant, a roller rink, a swimming pool, and a Turkish bath.

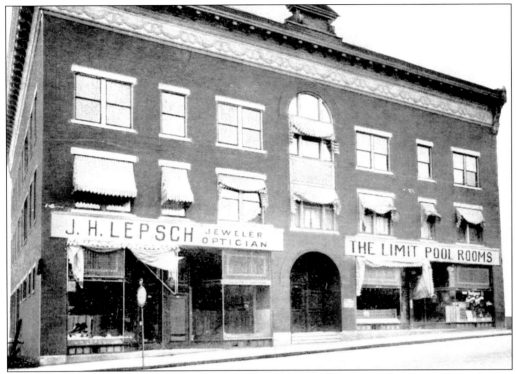

The Lepsch-Gardner Building was located on North Broad Street in Ridgway where the fire hall stands today. The J. H. Lepsch Jewelry Store and Optician was located on the ground floor, left side. Note the clock on the pole outside the establishment. A billiard hall called the Limit Pool Rooms occupied the ground floor, right side. The building burned and was replaced by the Ridgway Fire Department Hall. (Mark Wendel.)

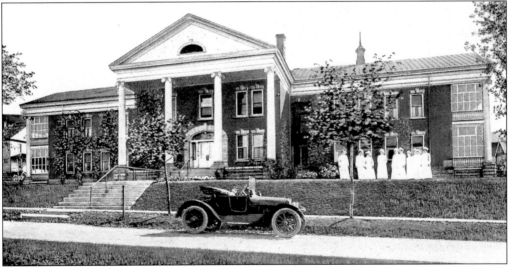

Local architect H. C. Park built the first Elk County General Hospital in Ridgway in 1901. An adjacent nurses' home was built in 1907. Additions to the hospital were built in 1925 and 1959. In 1980, the 1959 building was renovated, with the 1901 and 1925 buildings removed for parking. Today the complex is part of the Elk Regional Health Center. (Glenn Freeburg.)

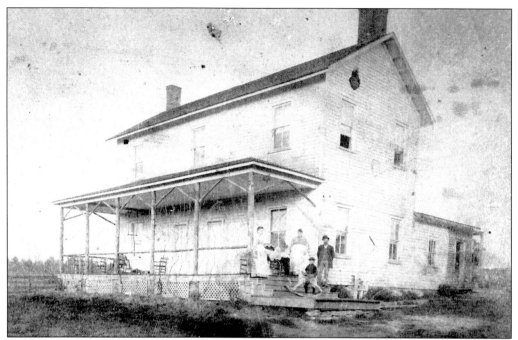

Ridgway started here. This is the only known photograph of the James Lyle Gillis farmhouse. Gillis was the agent for Jacob Ridgway, a wealthy Philadelphia Quaker and land speculator. Jacob Ridgway sent Gillis to begin the town that would bear his name. This farm was where Gillis founded the town on Montmorenci. The center of town would later be moved to a more favorable site on the river.

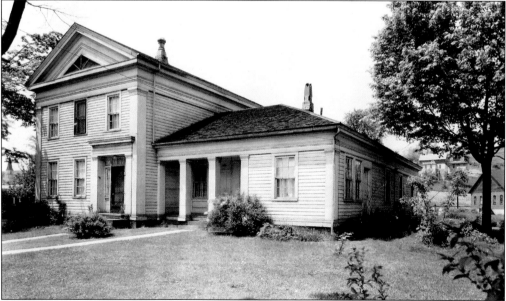

The oldest surviving private residence in Ridgway Borough is the George E. Dickinson home on West Main Street. The elegant Greek Revival structure was built by the early lumber pioneer from Connecticut. The corner pilasters of the main section of the house support a Greek-temple-inspired pediment. It has been lovingly restored inside and out. (Tim Leathers.)

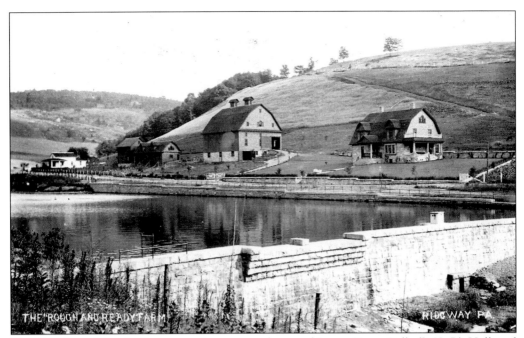

The Rough and Ready Farm was the summer home of James Knox Polk (J. K. P.) Hall and is located on Gallagher Run at the end of Hyde Avenue in Ridgway. The Dutch Colonial Hall farmhouse is shown at the right of the photograph along with its barn and outbuildings. The breastworks of Hall's Dam are in the foreground. The lake also included a boathouse. The hill behind the farm is forested again today. (Dave Woods.)

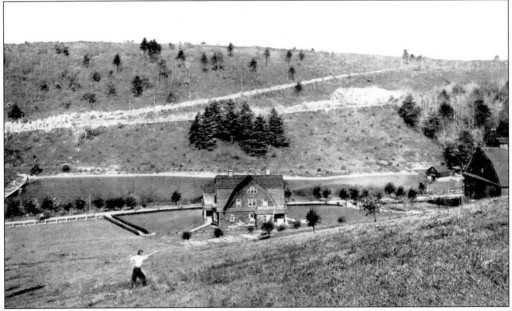

This is a view from behind J. K. P. Hall's Rough and Ready Farm. Behind the boy in the field pointing is the farmhouse and barn with Hall's Dam in the background. A boathouse is on the lake at right. At the top of the photograph one can see Boot Jack Hill Road, present Route 219, and above that a road angling up Searfoss Hill over to Mohan Run. (Glenn Freeburg.)

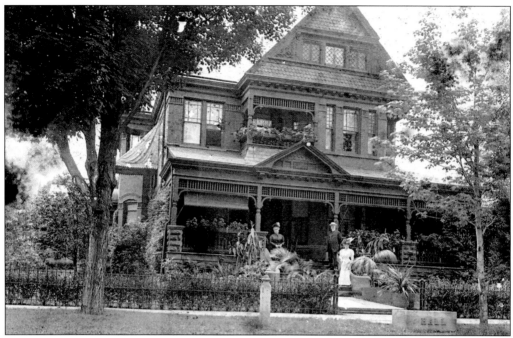

This is the home of J. K. P. Hall on East Main Street in Ridgway. Hall was a state senator and important early entrepreneur in Elk County. Hall, his wife, Kate (right), and her mother, Jane Hyde, can be seen on the steps of the mansion. At the curb is a carriage stone bearing the family name. Note the lush greenery decorating the large front porch and second-story balcony. (Glenn Freeburg.)

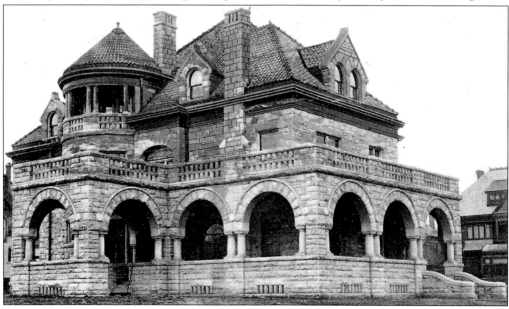

The Romanesque Hyde mansion on Main Street was built in 1907 by W. H. Hyde and constructed of greystone. Hyde was a state senator and son of early lumber pioneer Joseph S. Hyde. This view shows the massive front porch with porte cochere. Included is a three-story tower that is part of a third-story ballroom. It features Hyde-Murphy woodworking inside. The roof is of terra-cotta tile. (Dave Woods.)

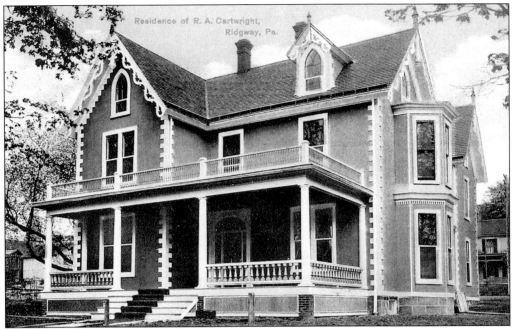

This is the residence of R. A. Cartwright on Center Street in Ridgway. The home stood where the Centennial High School was built (today being used as the courthouse annex). This Gothic Revival house featured pointed-arch windows, dormers, gables, decorative quoins, and gingerbread trim. It also had a large front porch across the entire front of the house and a full second-floor balcony. (Dave Woods.)

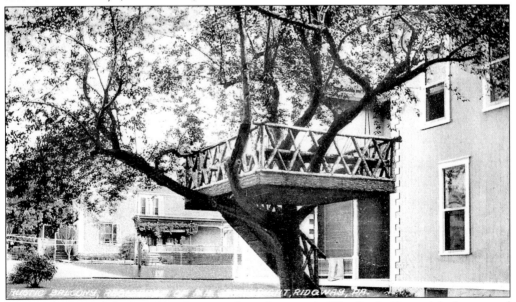

This is the rear of the home in the preceding photograph. The R. A. Cartwright homestead was on the corner of Center and South Broad Streets. This residence had a unique, rusticated balcony that was built onto the second floor of the home and supported by a massive tree instead of pillars. The balcony also had a stairway alongside the tree trunk to reach the balcony from the outside. (Mark Wendel.)

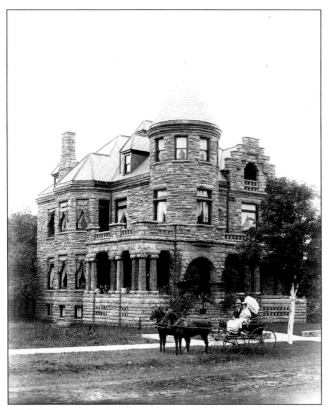

This is the Calvin McCauley mansion built by the Hyde-Murphy Company of pink brownstone on Main Street in Ridgway. The home was later the residence of Samuel P. Murphy, son of Walter P. Murphy, cofounder of the Hyde-Murphy Company. This home featured a three-story round turret and a Turkish theme room. A horse-drawn carriage arrives at the mansion including a well-dressed lady with a parasol.

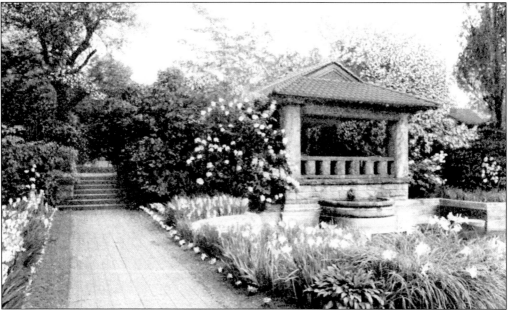

The Samuel P. Murphy estate gardens included walkways where one could get lost amid the profusion of flowering plants and trees to enjoy the birds and fragrant fresh air. Coming off of one end of the Japanese-style gazebo is a fountain with flowing water to add to the natural ambiance of this sylvan escape. (Glenn Freeburg.)

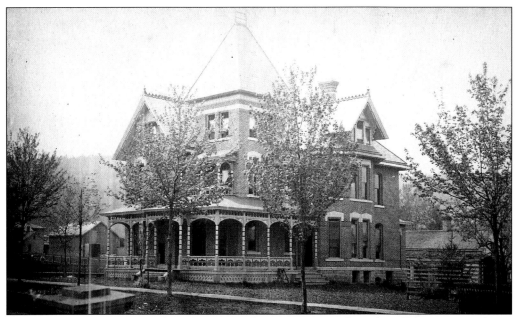

The Thompson mansion stood on the corner of Center Street and South Mill Avenue in Ridgway across from the present post office. It was a very large Victorian structure with a prominent tower and a large wraparound porch that covered most of two sides of the building. This beautiful, unique residence is among the many priceless treasures of Ridgway architecture that have been lost to time.

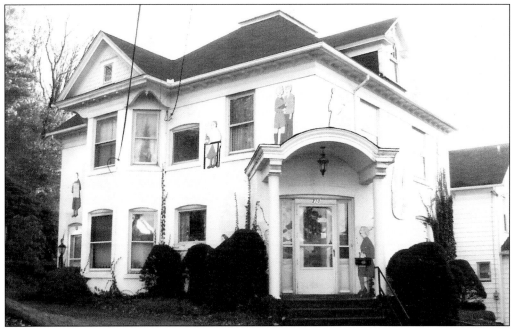

This is the home of Marie Davis at the corner of Metoxet and Spring Garden Streets. Davis was an ardent feminist, artist, and antique collector. Her home was a virtual museum. Life-size wooden cutout appliqués of feminist heroes decorated the outside of her house along with captions to inform passersby of important personalities in women's history. (Dennis McGeehan.)

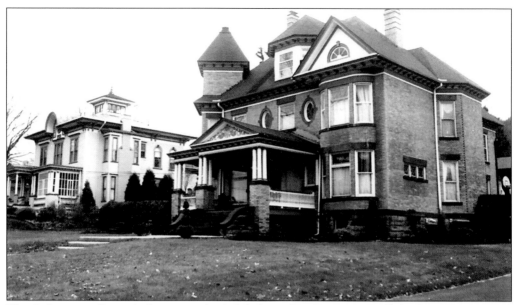

The Italianate villa–style home on the left belonged to Jerome Powell, built in 1865. Powell came to Ridgway to found the newspaper the *Elk County Advocate*, the forerunner of the *Ridgway Record*. He also amassed a fortune in lumber, mercantile, and real estate. His son Edgar Powell's Victorian mansion on the right was built in 1903. Both father and son served as mayor of Ridgway. (Dennis McGeehan.)

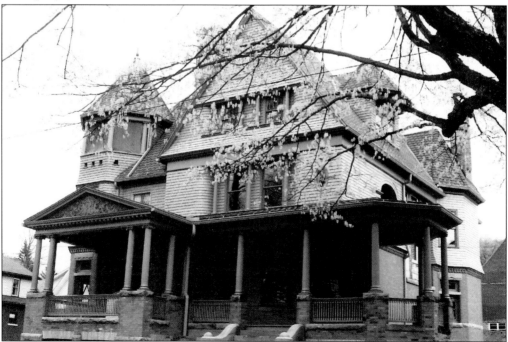

David Robertson built this grand house on Center Street in Ridgway in 1891. Robertson was the superintendent of the Dagus Mines coalfields in Fox Township. When it was built, the home was listed as one of the top 10 architectural wonders of the year in Pennsylvania. The home has recently been restored to its former grandeur. (Dennis McGeehan.)

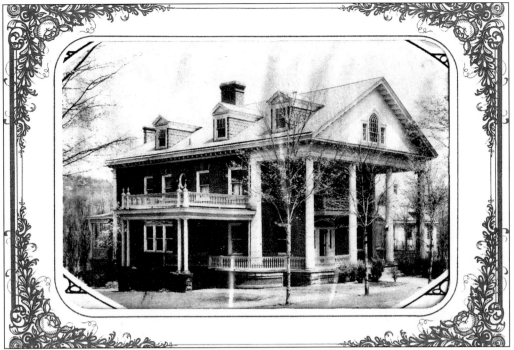

This Colonial Revival home was built in 1905 for Madison S. Kline and later acquired by the Hall family. Kline was a banker and sales manager for the Russell Car and Snow Plow Company. The entrance leads to a spacious reception hall. The large Ionic columns on the exterior support its third-story ballroom. Since 1922 this building has been the home of the Ridgway Public Library.

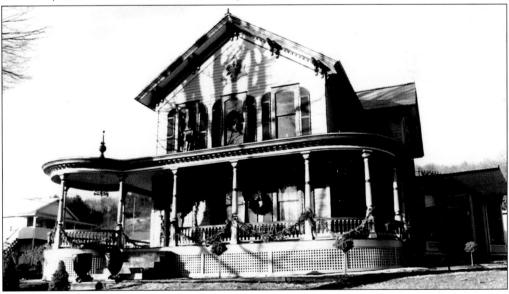

This sprawling mansion with the wraparound porch on Main Street in West Ridgway was the residence of O. B. Grant. Grant founded the Grant-Horton Tannery, also known as the Ridgway Tannery, with George Horton in 1867. This business later became part of the Elk Tanning Company. Grant became president of the Union Tanning Company. Grant Park in West Ridgway is named after him. (Dennis McGeehan.)

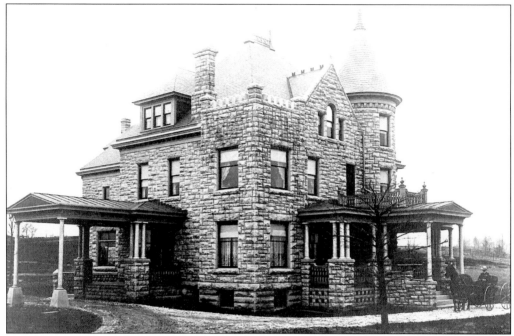

Bonifels, also known locally as the "Castle," was the home of Norman T. Arnold. Arnold was a teacher, lawyer, and judge. The Victorian mansion was built of greystone, brought in from Vermont by train, hauled up the mountain by wagon, and cut on the property. The site commands an imposing view of Ridgway. The building was later used as the Ridgway Country Club. (Glenn Freeburg.)

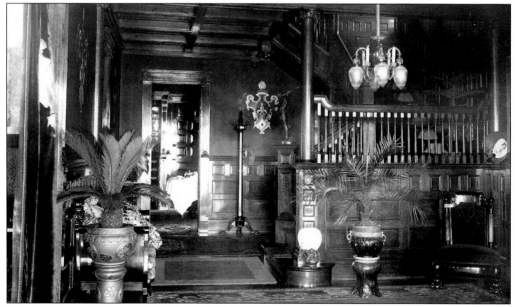

This is the grand front hall in the Bonifels mansion with its elaborate stairway incorporating a newel post figurine. The staircase was featured in a Hyde-Murphy advertisement showcasing their work. It was designed by William Minor. The Elk County Footlighters used the mansion to stage plays for limited audiences in the past. Note the fancy coffered ceiling. (Glenn Freeburg.)

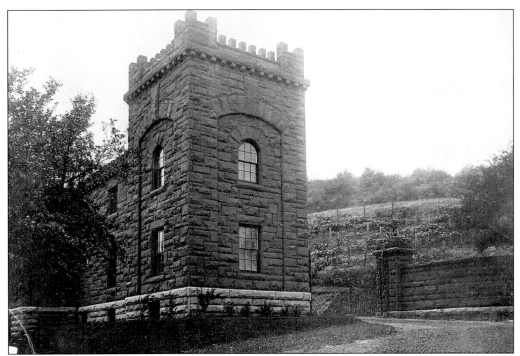

This structure, known as the "Lodge," was the gatehouse for the Bonifels mansion and estate. It was built of rose brownstone and also served as the home of the grounds' gardener, Hugh Girton. The road up the mountain is the present Laurel Mill Road, which was primitive at this time. Note the vineyards behind the gatehouse. (Glenn Freeburg.)

This is a detail from the William Healy mansion on Montmorenci Avenue, one of the largest Victorian clapboard houses in Ridgway and a treasure of architectural detail. It has recently been restored and painted with colorful hues. The building features highly decorative woodwork, brackets, gingerbread moldings, and shake shingles. The five-over-five, leaded, blue and red stained-glass windows are ornamented by a sunburst design. (Dennis McGeehan.)

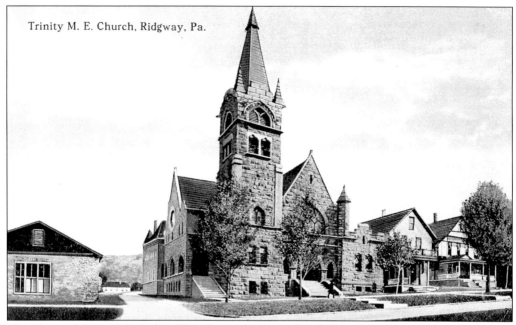

The Trinity United Methodist Church was built on South Broad Street in Ridgway in 1903. Originally known as the Methodist Episcopal Church, it is built of Hummelstown brownstone. Inside is a beautiful stained-glass domed ceiling. The cobblestone building on the left was the original slaughterhouse for the Hall, Kaul and Hyde Store, which was located next door. (Glenn Freeburg.)

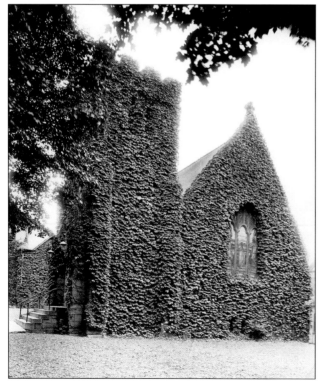

The second church built by the Grace Episcopal Congregation in 1905 was built on the same two lots on Center Street. John J. Ridgway, son of the founder of the town, Jacob Ridgway, had originally donated the lots for a church and rectory. The church eventually was covered in ivy, giving the church a colorful look. The ivy is gone today and the church has its original appearance.

The Bethlehem Lutheran Church was built in 1913 on the corner of South Broad and South Streets. For many years, the services were conducted in the Swedish language. The handsome redbrick building has two asymmetrical steeples and beautiful stained-glass windows. This is the congregation's second building. The parsonage is located beside the church.

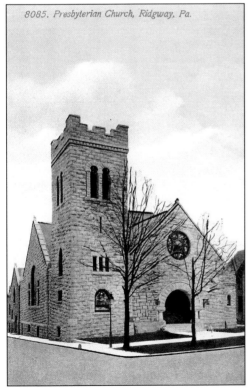

When the wooden First Presbyterian Church was destroyed by fire in 1909, this handsome stone structure was built on the same site on Center Street and dedicated in 1911. The building is Romanesque in style and has a massive, crenellated bell tower with a beautiful rose window over its entrance. (Glenn Freeburg.)

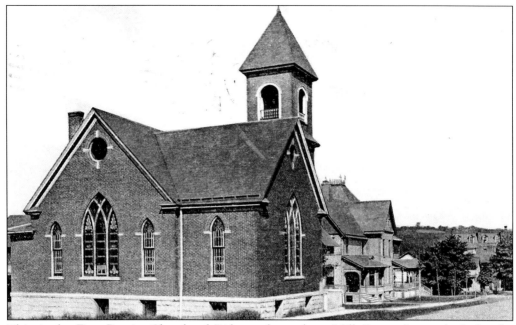

This is the First Baptist Church of Ridgway located on Mill Street. It was built by the Hyde-Murphy Company. It features three-sided Gothic Revival stained-glass windows and a tall bell tower. It later became the Christian Missionary Alliance Church before they outgrew the building and moved to Boot Jack Hill. This church building has been converted into a private home. (Dave Woods.)

The first St. Leo Magnus Church in Ridgway was built on Depot Street in 1883 on land donated by Dr. C. R. Earley. It was dedicated on August 12, 1883, by Bishop Mullen. This church was destroyed by fire on December 22, 1940, and a new building was planned immediately and rose on the same site two years later. The building on the right is the church rectory.

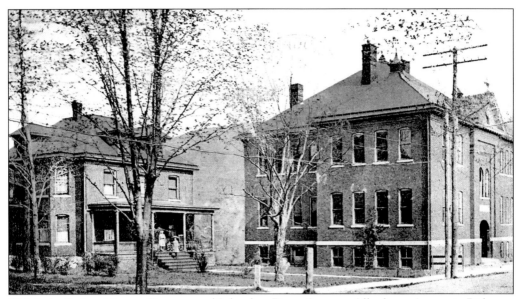

This is the St. Leo Magnus Convent and School on Depot Street at Allenhurst Avenue in Ridgway. This large brick building held classes from 1904 until 1962 when all Catholic high schools in Elk County were consolidated in St. Marys at the Elk County Christian School. The convent building on the left in this photograph was also used for preschool and grade school at times.

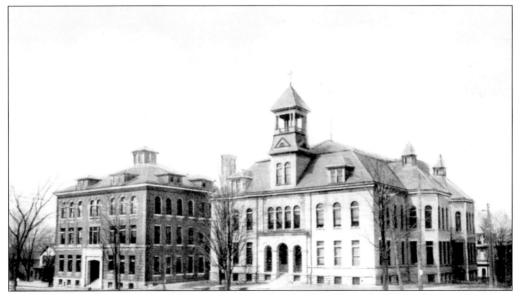

On the right is the 1899 school known as Central School, and on the left is the 1909 Ridgway High School building. The 1909 building was torn down in the early 1960s and the lot was turned into a playground. The Central School was refurbished, had the tower removed, and today is the Udarbe Complex, which houses offices.

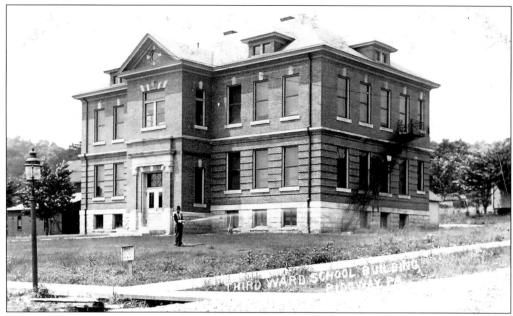

A gardener is shown watering the lawn at the Walnut Street School. This school was constructed in 1909. It consisted of a two-story brick building that contained four rooms and served as an elementary school until 1963, when there were too few students in those grades. However, the building continued to house kindergarten classes until 1974. From 1963 until 1979 the second floor held the school superintendent's office. (Glenn Freeburg.)

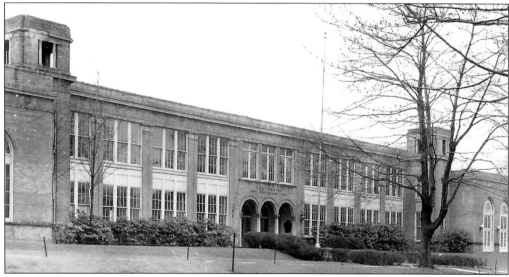

The Centennial High School, on Center Street, was built in 1924 and named to celebrate the 100th anniversary of the founding of Ridgway. It served Ridgway's high school needs until 1961 when a newer building was dedicated as the Ridgway Area High School at Hill Street and Fillmore Avenue. Today the county utilizes the old high school building on Center Street as a courthouse annex.

Three

THE BONDS OF SOCIETY

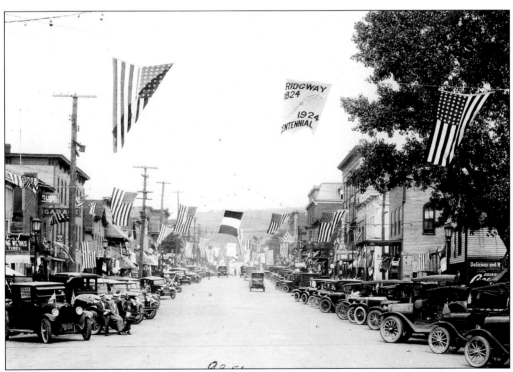

Ridgway celebrated the centennial of its founding in 1924. The event was highlighted by many events including a grand parade, speeches, and many other festivities. This scene shows the profusion of American flags and banners as well as an automobile-lined Main Street. This view is looking east on Main Street.

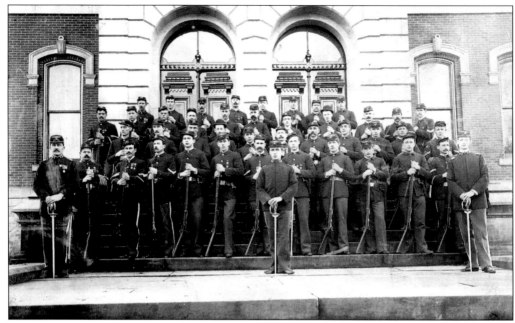

Veteran soldiers and officers from the Civil War gather for a reunion in front of the Elk County Courthouse in Ridgway in the 1890s. Their uniforms still fit and the only changes are the medals pinned on the honored blue coats. Their rifles are still their most prized possessions. The Grand Army of the Republic was a veterans' organization that met for many years after the war.

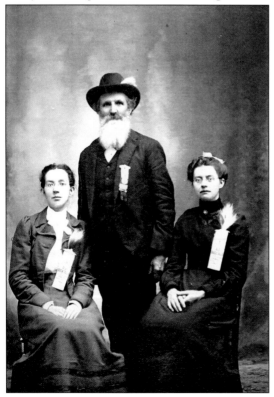

Elijah "Lige" Brookins is shown in his Grand Army of the Republic veteran's uniform. He is shown with his daughters Hattie (left) and Alice. The bucktail sticking out of his hat signifies that he was a member of that legendary regiment. Thomas L. Kane raised the Bucktails partly in Elk County.

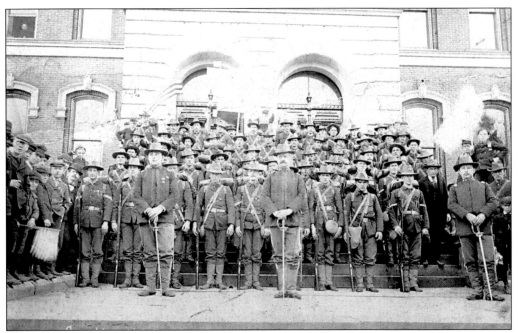

Company H of the 17th Regiment Pennsylvania National Guard musters on the steps of the Elk County Courthouse in Ridgway on April 27, 1898. This company of soldiers from Ridgway was called to duty in the Spanish-American War and saw action in Puerto Rico before returning home in October of that year.

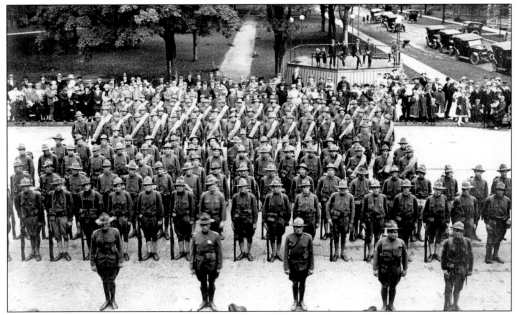

Ridgway's National Guard was mobilized in response to a call from the president on July 15, 1917. Company H 16th Regiment of the Pennsylvania National Guard is shown on the day of their entrainment for Camp Hancock, Georgia, for oversees duty in World War I. They mustered on Main Street in front of the courthouse. The men fought bravely and most returned home after the war.

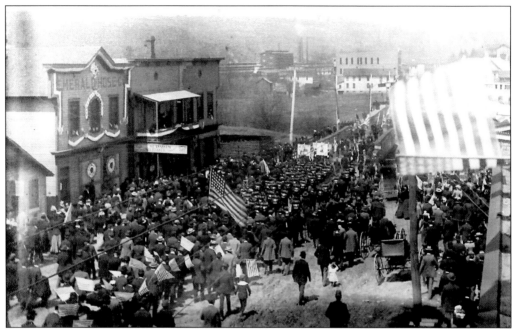

This is the scene on North Broad Street in Ridgway in 1898 as soldiers depart for the Spanish American War followed by a large crowd of well-wishers as the American flag snaps in the breeze. The public followed them to the train station to wish them all a safe and speedy return. They are marching past the Emerald Hose Company and the Van Aken Undertaking business.

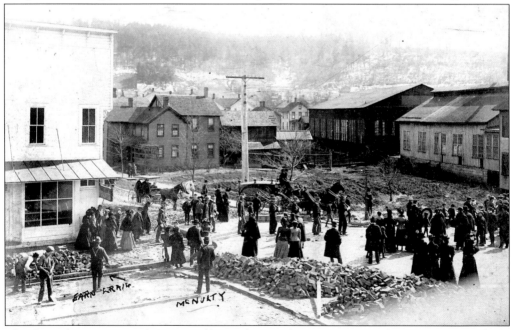

The funeral procession of Capt. William Sherwood Horton passes the intersection of Elk Avenue and Main Street in Ridgway on November 3, 1892. Captain Horton was a veteran and his cortege includes an honor guard and band. His final march has attracted a crowd of the respectful and curious. Road construction workers have stopped to witness the spectacle.

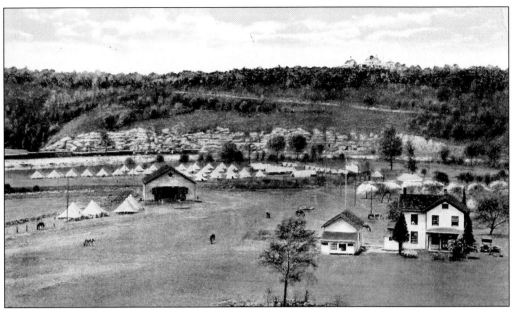

This is the 18th Infantry of the Pennsylvania National Guard at Camp Anderson in Ridgway. This facility was created to train U.S. servicemen for World War I. Note the horses grazing. At this time, cavalry was still important. Warfare had not yet become completely mechanized. Note in the background the Bonifels mansion of the Arnold family is visible on the skyline as well as the old road up to it. (Tim Leathers.)

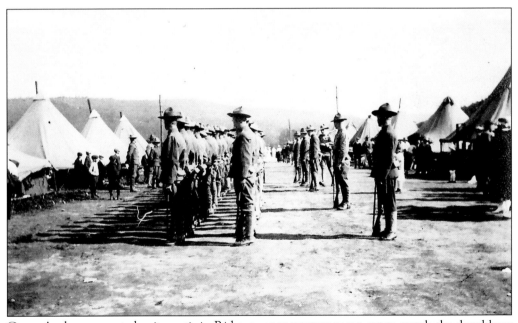

Camp Anderson created quite a stir in Ridgway as spectators came out to watch the doughboys drilling. Note the young boys in this photograph watching the young men train, awed by the spectacle, both innocent of the harsh realities of war. Excitement was mixed with fear in sending young men far away to meet other young men with the fervent hope that all would return. (Glenn Freeburg.)

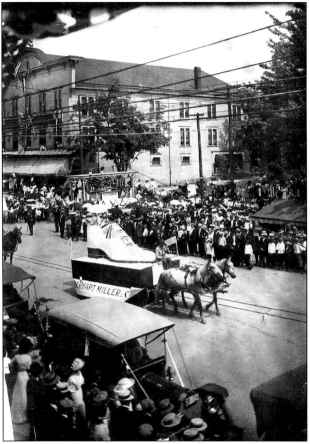

This parade in 1910 on Ridgway's Main Street shows the float of the Eberhart and Miller Shoe Store. The building in the background was originally J. S. and W. H. Hyde and Company, later the Hall, Kaul and Hyde store, the Smith Brothers Company, and the Clawson and Fisk store, before being torn down. This corner was later the Court Service Station, a Sheetz store, and today is the Ridgway Chamber of Commerce/Welcome Center.

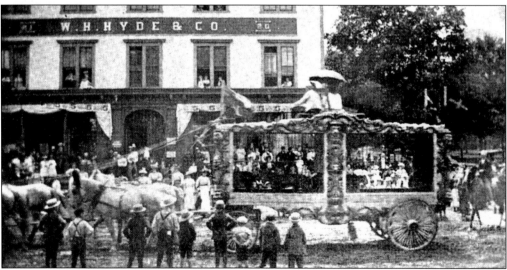

When the circus came to town, the spectacle drew large crowds to watch the colorful circus wagons, clowns, and elephants parade through town to the big top on the tent grounds. In this scene, the tiger cage is being pulled past the W. H. Hyde and Company store. Young and old alike have turned out for the excitement.

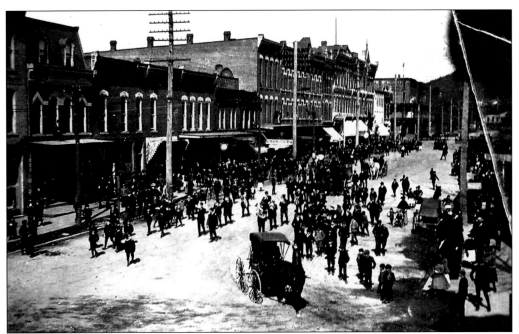

This parade is from the late 19th century and is proceeding along a dirt Main Street in Ridgway, turning onto Mill Street. The view is looking east and was taken from the Ross House, later the Salberg Hotel where the Northwest Bank is today. There is a marching band and several horse carriages in front of the Elk Countys Courthouse and Ridgway's commercial downtown district.

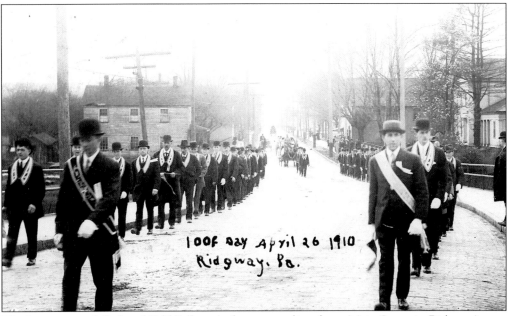

The International Order of Odd Fellows is shown parading down Main Street in Ridgway's west end on April 26, 1910. It was a somewhat muted celebration and somber parade as the huge Hyde-Murphy fire had taken place only three days earlier. This fire had burned a large part of the downtown, but the parade must go on. The building on the left is George Dickinson's store. (Tim Leathers.)

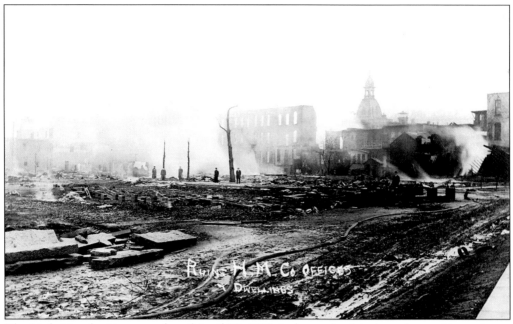

The Hyde-Murphy Company fire of April 23, 1910, is shown. In this shot, the smoking ruins at ground zero of the conflagration are shown with blasted trees and charred foundations, all that is visible to spectators, with the Elk County Courthouse tower looming in the background. The smoldering rubble smoked for days. (Dave Woods.)

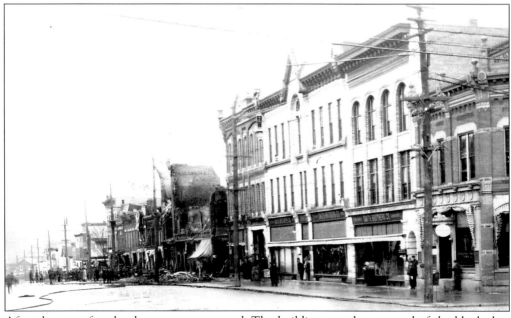

After the great fire the damage was surveyed. The buildings on the east end of the block that escaped damage from the fire are, from right to left, the Elk County National Bank, the Smith Brothers Company Department Store in the Grand Central Building, and the Schoening and Maginnis Union Hall Building. They remain today in the heart of the historic district in downtown Ridgway. (Dave Woods.)

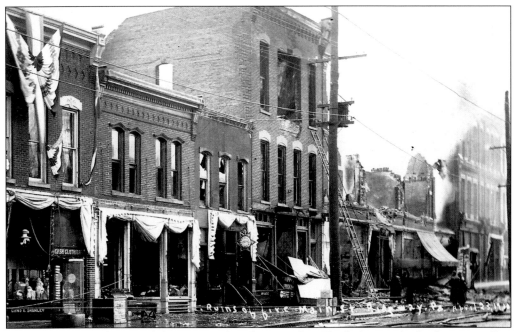

Here is Ridgway's decimated downtown after the great fire. The holocaust had a dramatic affect on the look of Main Street in Ridgway. This photograph shows the area of Main Street that was destroyed. The building on the left was saved. All buildings to the right had to be removed or rebuilt, changing the skyline of downtown Ridgway forever. (Dave Woods.)

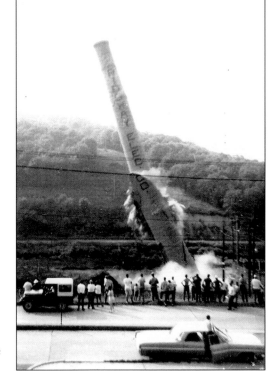

Here is the scene on July 25, 1963, when the Ridgway Electric Company's power plant lost its smokestack after it was no longer needed and was dynamited. A small group of onlookers has gathered to witness the implosion of the old landmark and see the chimney come down. The old building of the company had come down sometime earlier.

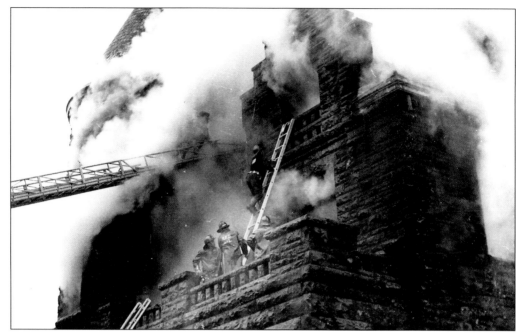

Firemen battle the blaze that is engulfing the Samuel Murphy mansion on the east end of Main Street in Ridgway on December 15, 1956. A heavy truck, descending Boot Jack Hill, lost its brakes and crashed into the home setting it ablaze. The Murphy family had to be rescued from the burning structure. Sadly, this beautiful landmark structure could not be saved and had to be razed.

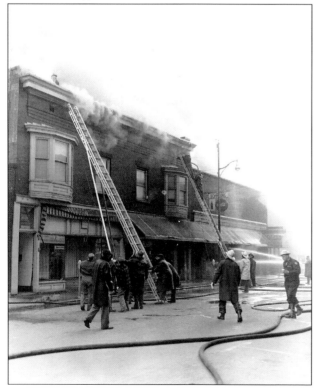

Ridgway firemen are seen fighting the Aiello's Bar and Bowling Alley fire, at right on North Broad Street. The S. K. Tate Furs Building at left was saved and today houses Jenny Lin Antiques. Aiello's rebuilt on the same site. Ridgway is well protected by one of the finest volunteer fire departments in the area and their annual celebration is a high point of Ridgway's social calendar.

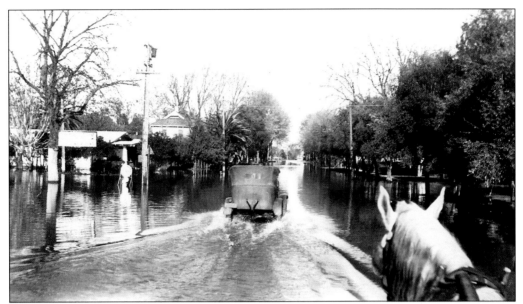

Ridgway, located at the juncture of Elk Creek and the Clarion River, suffered from high waters frequently. In the 1950s, the East Branch Clarion River Reservoir was built upstream to relieve flooding in the watershed. In this scene, the horse appears to be waiting to see if the automobile makes it through before attempting the flooded roadway.

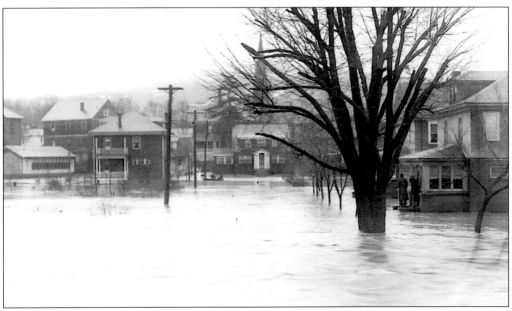

In this photograph from the St. Patrick's Day flood of 1936, Elk Creek has inundated the area between Erie and Allenhurst Avenues. The old St. Leo's Church steeple, before the church burned, can be seen in the background. This scene shows three men in a boat motoring down the street to rescue two men from the building on the right.

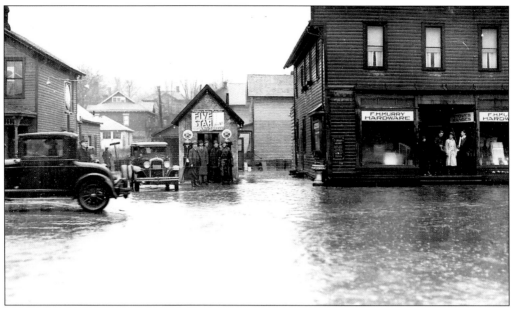

Rising waters are shown on Main Street in Ridgway before several groups of concerned onlookers. The F. H. Murry Hardware Store is shown on the right while the Five Star gasoline station is shown on the left. Some filling stations were quite small. The early automobiles are not stopped by water yet.

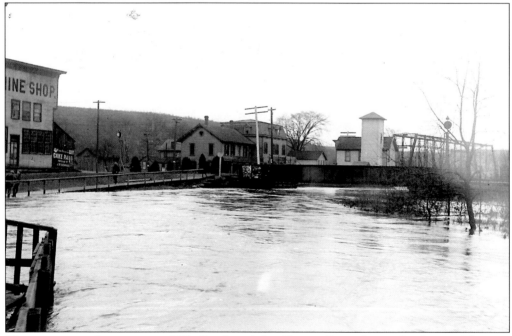

This scene is at the juncture of Elk Creek and the Clarion River during flood stage. The iron bridge over the Clarion is at the right, which had an adjacent tollhouse. The building at left, housing a machine shop, is where the *Ridgway Record* is located today. The building in the center is the Clarion House hotel on the banks of the river where Keystone Hardware is located today.

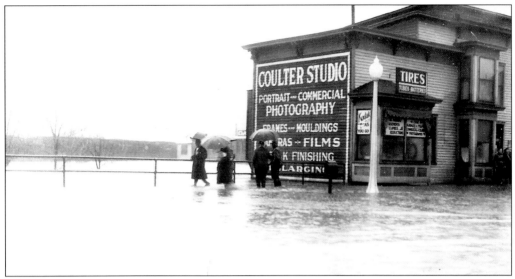

The Coulter Photographic Studio was located at the corner of Main Street and Elk Avenue. This scene at the studio is during the St. Patrick's Day flood of 1936. On this day, floods devastated western Pennsylvania and many towns were underwater. Flooding prompted the Army Corps of Engineers to build the East Branch Dam on the Clarion River upstream from Ridgway.

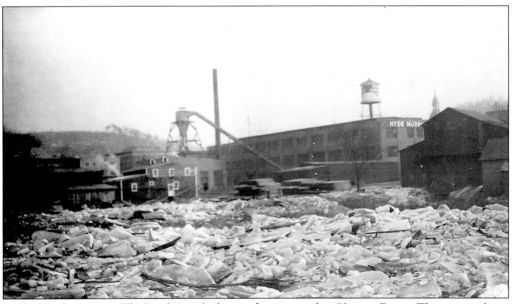

Gallagher Run joins Elk Creek just before it flows into the Clarion River. There was also a millrace and a large millpond for the Salberg Grist Mill in the same area that today is the firemen's grounds. This large ice jam is what happens when that much water meets in a small area during the winter. In the background is the Hyde-Murphy Company and the county courthouse tower. (Glenn Freeburg.)

This is a scene from the Easter sunrise service at the Anderson's Dairy Farm in 1956. Anderson's Dairy Farm was located on Montmorenci Road and the building still stands, although the dairy is no longer in business. The inspiring spectacle of three large crosses, the crisp spring morning air, and the fellowship of their congregation must have reinvigorated these peoples' faith.

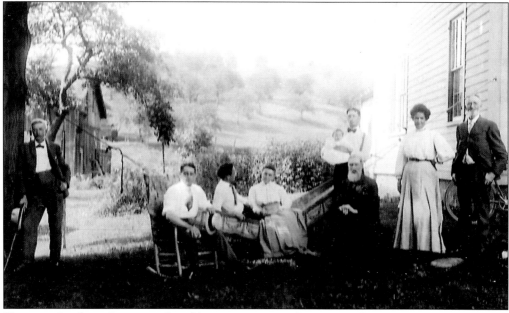

Here is a family gathering at the oldest surviving residence in Ridgway Borough, the George Dickinson home on West Main Street. The three men in dark suits are George's sons, from left to right, Will, George, and Ezra. Will was the well-known bridge builder and all three sons operated a sawmill at Laurel Run. Children and in-laws are seated on the hammock. Note the apple orchard in the background. (Tim Leathers.)

Here is a scene from the company picnic of an area business. This one seems to be for the upper management, as they seem pious and reserved. Companies often had gatherings to celebrate a good year, reward the workers, and build team spirit for the coming year. This gathering even uses fancy china and has decorated the picnic table with ferns.

This is the company picnic of the same business as the preceding photograph. It is probably for the general workforce. A keg of beer becomes a seat for the partygoer in the front row, and everyone has a mug of the liquid refreshment in hand. Many have brought musical instruments to liven up the scene. The well-dressed gentleman always wore a hat, even at leisure in those days.

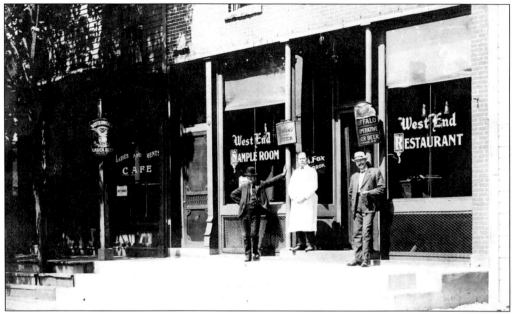

A. Fox, center, is seen in front of his establishment, the West End Restaurant and Sample Room. To the left is a sign, Ladies and Gents Café. It was common to have separate entrances and even separate seating by gender in drinking parlors. Beers available to be sampled included Dotterweich Lager Beer of Olean, New York; Geilein's Beer of Cincinnati, Ohio; and Buffalo Cooperative Lager Beer of Buffalo, New York.

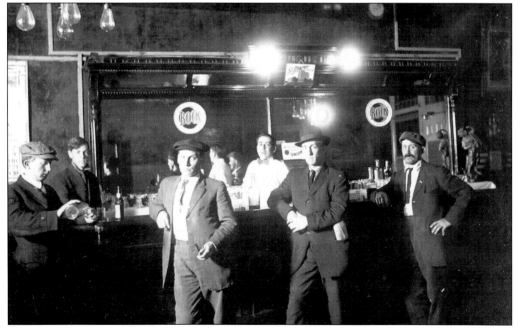

These gentlemen are imbibing at the Bogert Hotel Bar. All of the patrons are wearing coats and ties. It was a more formal era. Most bartenders wore ties back then. Early electric lights are in use, although bars are still generally dark. Behind the bar, a sign advertises the popular area product, St. Marys Beer.

A sympathetic bartender with a friendly ear offers much needed solace after a hard day on the job. This barman offers brew, spirits, cigars, and insight at the Clarion House Bar. The time is May 1909 as noted by the Wisconsin Central Railway calendar behind the bar. An indifferent whitetail buck passively looks on.

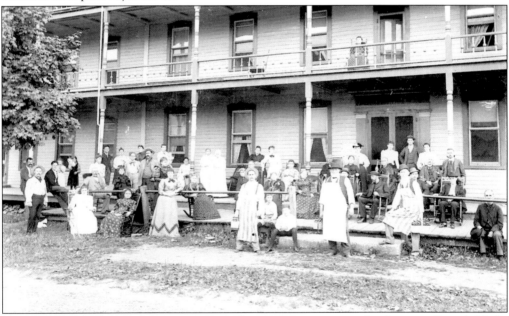

The Home for Suffering Humanity on Front Street was a sanitarium for the poor, ill, and elderly. Residents are seen with rocking chairs, wheel chairs, and crutches. It also appears that family members are visiting. A man in the front row is holding a basket of elixirs, medicines, or liquid refreshment. Three men in aprons may mean it is mealtime. The building was later known as Herman's Tavern. (Tim Leathers.)

Relaxing barefoot with the family pet on a sunny summer day brings back memories of a simpler time. A big sister and a furry friend are all a little girl needs sometimes. This photograph was taken on the doorstep of an early home in the west end of Ridgway in the early part of the last century. (Tim Leathers.)

A photograph of two sisters to mark a special occasion is a treasured keepsake. However when the outfits are white dresses, stockings, shoes, and matching bows it is sometimes hard to hold the pose and smile. Keeping the uniform spotless is difficult and the models may be anxious to get back to their full-time profession of playing. (Tim Leathers.)

Fashions come and go and it always brings amusement and nostalgia to look at ancestors and the way they acted and dressed. This young lady obviously thought enough of her stylish outfit to have a formal studio portrait taken. Certainly the style of the time incorporated more fur and feathers than what one is used to today.

Might this be a fond memory of a Mother's Day from long ago, a familial call on grandmother to show her how successful her favorite has become, or just spending some cherished time in the garden with a respected aunt? Maintaining the bonds between generations are customs that keep communities like Ridgway thriving. (Tim Leathers.)

An infant of indeterminate gender is shown in amazingly resplendent nightclothes. If it is a little boy, the look of apparent confusion on the child's face is understandable. In the early 1900s, children were worshipped and pampered and often dressed up like little dolls to be shown off to relatives and friends by their proud parents.

These fashionable little girls strolling down a Ridgway street are the height of good taste for preschoolers of their era. Complete with stylish dresses and fancy bonnets, they parade their finery for all of the jealous models of their neighborhood to see. It is a beautiful day for a promenade as long as a delicate parasol is handy to shield them from the summer sun for these tiny arbiters of taste.

No, this is not the top of a wedding cake. Tom Thumb weddings were a fad for a brief time in the past. Tom Thumb was a famous circus performer, and otherwise sane adults thought it would be cute to dress children up to stage a wedding fashion show. The look on the faces of this tiny bride and groom suggest that it was mostly for the parents' amusement.

These mailmen are loaded down with letters and parcels during the Christmas season. This scene is from 1904 when the Ridgway Post Office was located in the Ridgway National Bank Building on the corner of Main and Court Streets. A little bit of snow can be seen on the ground, but neither rain, nor snow, nor sleet will stop the delivery of these seasons greetings.

Two gentlemen of the sporting life take a break from their day of rambling afield and shooting sports to contemplate the outdoor life in front of a handy photographer in 1897 near Hyde Lake. With their jaunty hunting caps askew, they only have time for a quick pose before they are off again in pursuit of the elusive quarry.

A pair of Elk County hunters set out afield for a day's sport with their faithful hunting dogs. The woods and fields of the Ridgway area afford ample opportunity for sportsmen to listen to the sweet music of a well-trained hound working the hills and hollows of the Allegheny highlands.

Camp architecture is very varied in the Elk County area. There are many of these temporary quarters scattered through the woodlands of the region. Often empty through much of the year, for the first week of fishing or hunting season the camps fill up as Elk County's population swells for the seasonal ritual. This is a more substantial brick structure.

Here is an idyllic hunting camp scene. Two bird dogs patiently wait on the porch for their masters to return and take up their posts rocking on the front porch reliving the day's endeavor. A man and his dog communing with nature in the wilderness is a perfect day for the happy nimrod. (Glenn Freeburg.)

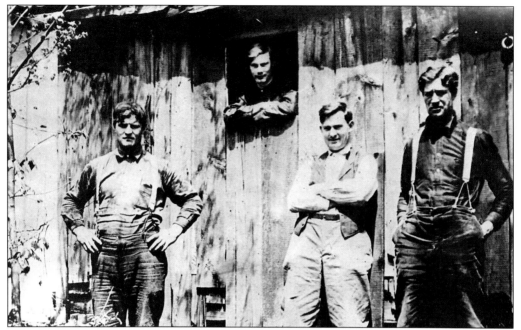

A group of young men enjoys the hunting camp they have knocked together. Hunting camps were often crude shacks that were added to and improved over the years of hunts. All that was needed at first was a place to sleep until dawn to begin hunting the hollows. These men improve their shack over the years and collect and embellish hunting stories to tell each other in their golden years.

A group of men poses for a photograph at an area hunting camp. Possibly these men are old friends who have been getting together for many years to spend some time together pursuing the outdoor sports. They have possibly raised many dogs for the hunt and their camp mascot is the youngest in a line of man's best friends they have cherished. They are probably retelling old hunting stories over a pipe full of tobacco.

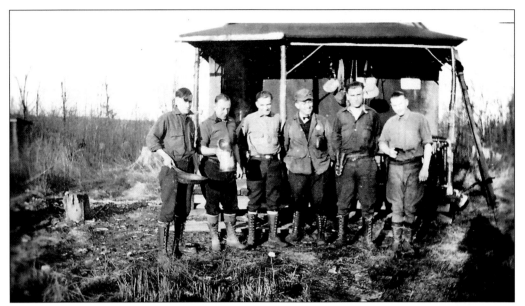

Part of the attraction of hunting is to get away from the workplace briefly with a group of friends to inhabit a too-small shack in the woods and endure Spartan living conditions to get some exercise, fresh air, and, hopefully, some fresh venison. The camp cook took great pride in his duties to furnish hearty meals for the crew.

After an invigorating day afield, nothing is as satisfying as outdoor cooking. A wood fire is the very best seasoning. Culinary arts under primitive conditions create legendary outdoor chefs. The smell of fresh wild game is the reward for a successful hunt. This meal features brook trout, venison sausage, and plenty of hot black coffee, local favorites.

Hunting is a big business in Pennsylvania. Elk County and Ridgway benefit from the yearly influx of deer hunters for the annual season. These hunters are showing off a pair of nice bucks harvested from the local woods. The nearby Allegheny National Forest is famous for its deer hunting. Although this photograph is in black and white one can be sure it was before the days of blaze orange.

Hunting, fishing, wildlife watching, canoeing, hiking, and camping are just some of the recreational pursuits that attract many tourists to the Elk County area. The region's economy has had a big boost since the creation of the Pennsylvania Wilds Heritage Region. A camping trip that resulted in catching the big one will become a childhood memory from the Wilds that will last a lifetime.

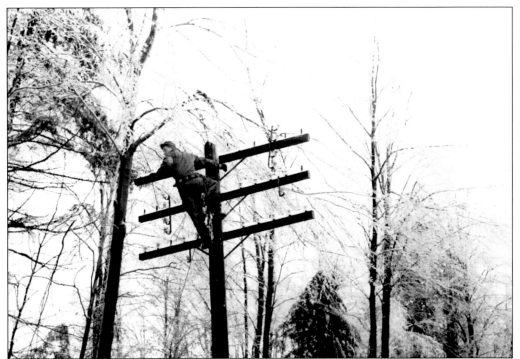

Malcolm Earl Amacher is seen repairing telephone lines for the Home Telephone Company after a devastating and beautiful ice storm struck over a wide area of north central Pennsylvania in 1950. Utility lines and tree limbs were down in many places. It looks like a cold and hazardous job restoring service to customers.

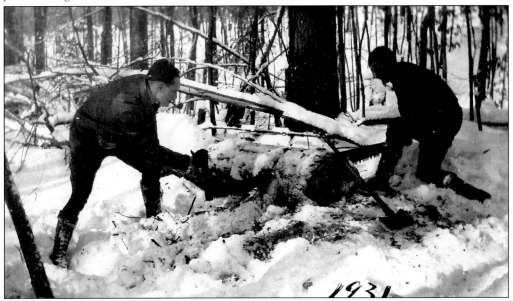

A pair of lumberjacks is using a crosscut saw in the winter woods in 1931. Pennsylvania was blessed with abundant forests that made many a fortune during the logging era. Ridgway's early wealth was based on the timber industry. Today Ridgway hosts a Chainsaw Carvers Rendezvous in February that attracts chainsaw carvers from around the world.

This little tyke beaming with joy with his fancy sled is Perrin Shanley, future mayor of Ridgway. All is right with a child's world when he receives a new sled and snow for Christmas day. The sled is a Van Aken Easy Rider, invented by John Van Aken. The sled proved so popular that the item was manufactured in Ridgway and kept the employees busy turning out 200 sleds daily.

George Loichinger is shown with his horse and sleigh on the Ridgway–St. Marys Road. Winter maintenance was almost nonexistent in times past, and a good cutter with a reliable horse was usually the way to go. Formidable Elk County winters have never stopped local residents from going where they really want to go.

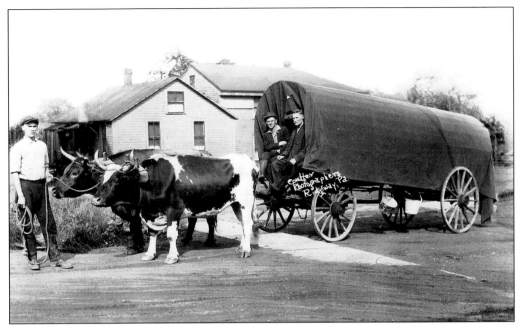

This 8-by-10-foot covered wagon being pulled by a span of oxen is seen navigating the streets of Ridgway. The man leading the animals is identified as C. A. Holtin of Ridgway. Oxen were commonly used in the early farming life of the community. This photograph was taken by the Coulter Photography Studio, which was located at the west end of Main Street in Ridgway.

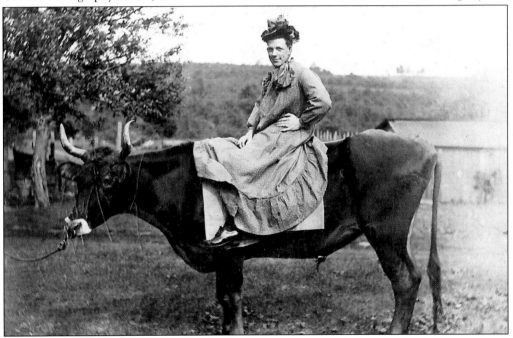

Transportation was different back then and sometimes ancestors had to improvise to get around. Farming was never the easiest of lives and the pioneers that cleared the forests and broke the soil are often portrayed as an inflexible and dour lot. However, the hint of a smile on this person's face is all one needs to realize that these salt-of-the-earth folks had their moments of levity.

Two happy passengers in ornate showy strollers take in the sights of Ridgway's Main Street with their proud father. Ridgway's founding planners had the foresight to design broad, tree-lined streets, which has made the town a joy for pedestrians, motorists, and shoppers. Ridgway is famous for its parades on its spacious Main Street.

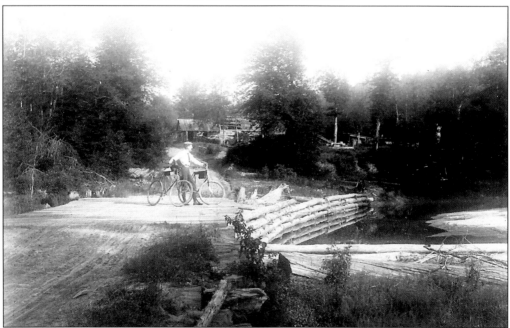

This bridge was located on Big Mill Creek near where the Dickinson Brothers sawmill was located. These three brothers—George, Ezra, and Will—were the sons of early lumber pioneer George Dickinson Sr., whose business was in Ridgway's west end. This site today has been developed into the Sandy Beach Recreation Area.

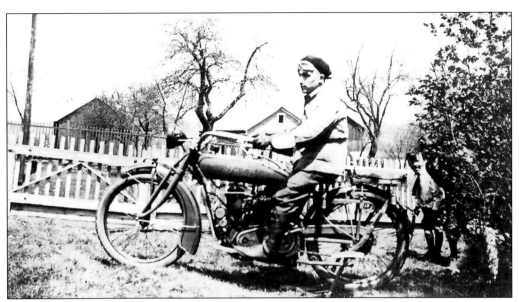

Some seek the thrills that only fewer wheels can provide while navigating down life's highway. An early motorcyclist from Ridgway is shown on an old Indian motorcycle. Two-wheel touring was more arduous back when many of the area roads were unpaved and the driver was also the mechanic. The little boy peeking behind the bush looks as excited and adventuresome as the proud cyclist. (Glenn Freeburg.)

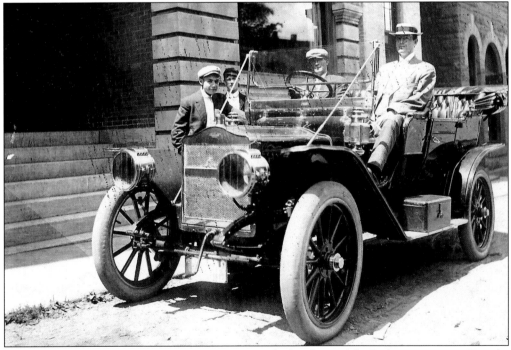

These unidentified motor-sports enthusiasts are parked in front of the Ridgway Masonic Temple. Note the crank on the front of the automobile to get the engine started and the toolbox on the running board for the frequent breakdowns. The headlamps, windshield, and convertible top all appear flimsy by today's standards. The steering wheel is also on the wrong side.

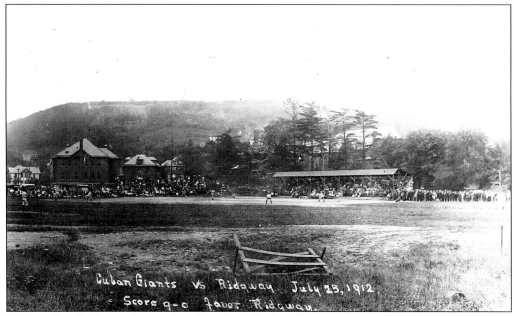

Here is a baseball game being played on the Allenhurst Avenue Baseball Field on July 25, 1912. The opponent was the Cuban Giants, with the final score 9-0 in favor of Ridgway. Traveling teams of players from Cuba or other areas challenged local teams and these matches often drew large crowds to cheer on the home nine. Visible in the background are the old St. Leo's Church, steeple, and school. (Dave Woods.)

The Belvedere Roller Skating Rink was located on Boot Jack Hill just south of the intersection of Routes 219 and 948 (the Kersey Road). Later the business became the Belvedere Bar, and after remodeling, the New Belvedere, a bar and dance hall. The building has been torn down. Roller-skating was a very popular recreation in the past.

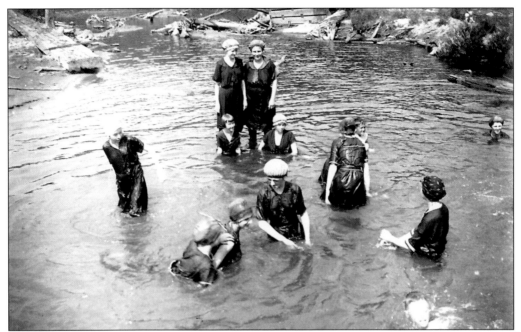

Laurel Mill was where the old swimming hole was in 1916. Before there were pools with chlorine and filters, there were pools with sand and mud. Naturally, a modest girl wore the proper attire for the day, a full swimming uniform complete with bathing cap. On a hot summer day the only thing to worry about were splashing boys and toe pinching crayfish.

Marshall's swimming pool on the Ridgway–St. Marys Road was a popular place on hot summer days. The pool featured two diving boards of different heights and a sliding board. The popularity of the place is evident in this photograph from early in the 20th century. Note the old-fashioned bathing suits and straw-hatted onlookers. A brass band performs at the upper right of this scene.

When Elk County was first developed, the inevitable runoff from the extractive industries of logging, tanning, and mining, combined with lax environmental laws, inevitably led to poor water quality. Today the Clarion River is a noteworthy example of the success of careful stewardship of the earth. The river has rebounded to become a recreational paradise. Dave Love's Canoe Rental does a brisk business to those who want to experience this wilderness treasure. (Dave Love.)

Ridgway is the gateway to the Allegheny National Forest. From Ridgway, one can paddle the Clarion River, designated a national wild and scenic river, to Cook Forest State Park, with its stand of virgin timber, while fishing, camping, swimming, or wildlife viewing along the way. The Clarion is a river of imagination. One can glimpse the ghostly past of this forest that lured pioneers to settle and stay. (Dennis McGeehan.)

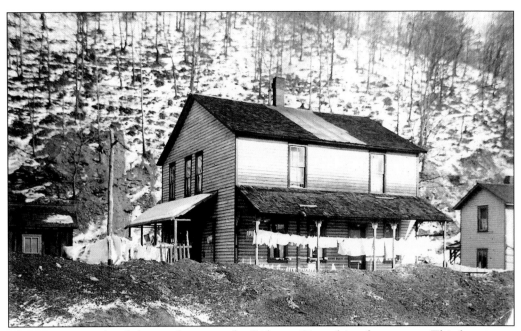

This is an example of the rural nature of a Ridgway Township of years ago. This house was located on the eastern edge of Ridgway Township in Daguscahonda along the Pennsylvania Railroad. There was a cluster of houses here for workers at the Elk Fire Brick Company. It appears to have been wash day in early spring before washing moved indoors.

Shown is an architectural detail from one of the many distinctive buildings in Ridgway that have earned the town the nickname "Lily of the Valley." This detail is from the Buffalo, Rochester and Pittsburgh Railroad passenger station, later taken over by the Baltimore and Ohio Railroad. This beautiful building is now used as part of the Dickinson Mental Health Center. (Dennis McGeehan.)

Discover Thousands of Local History Books Featuring Millions of Vintage Images

Arcadia Publishing, the leading local history publisher in the United States, is committed to making history accessible and meaningful through publishing books that celebrate and preserve the heritage of America's people and places.

Find more books like this at
www.arcadiapublishing.com

Search for your hometown history, your old stomping grounds, and even your favorite sports team.

Consistent with our mission to preserve history on a local level, this book was printed in South Carolina on American-made paper and manufactured entirely in the United States. Products carrying the accredited Forest Stewardship Council (FSC) label are printed on 100 percent FSC-certified paper.